FIFE CULTURAL TRUST

HJ477918

S⌐.

Please return or renew this item before the latest date shown below

S

VALLEYFIELD 3/17
ABERDOUR 10/17

T H

N

2 9 MAY 2017
SA –DP 23/5/17

2 AUG 2017
⇒DP

D1634584

Read the Past

Renewals can be made
by internet www.fifedirect.org.uk/libraries
in person at any library in Fife
by phone 03451 55 00 66

ON
AT FIFE
LIBRARIES

Thank you for using your library

AMBERLEY

FIFE COUNCIL LIBRARIES	
HJ477918	
Askews & Holts	10-Jan-2017
941.29 COO	£14.99
HIST	FIFE

For Hamish and Alison

First published 2016

Amberley Publishing
The Hill, Stroud, Gloucestershire, GL5 4EP
www.amberley-books.com

Copyright © Helen Cook, 2016

Postcards courtesy of the St Andrews Preservation Trust

The right of Helen Cook to be identified as the
Author of this work has been asserted in accordance with
the Copyrights, Designs and Patents Act 1988.

ISBN 978 1 4456 4576 6 (print)
ISBN 978 1 4456 4580 3 (ebook)

All rights reserved. No part of this book may be reprinted
or reproduced or utilised in any form or by any electronic,
mechanical or other means, now known or hereafter
invented, including photocopying and recording, or in
any information storage or retrieval system, without the
permission in writing from the Publishers.

British Library Cataloguing in Publication Data.
A catalogue record for this book is available from the
British Library.

Typesetting by Amberley Publishing.
Printed in Great Britain.

CONTENTS

INTRODUCTION

The Postcard Selection

Postcards are published to sell, and those chosen for *St Andrews: The Postcard Collection*, besides portraying some of the facets of an older St Andrews, indicate the parts of the town then most frequently visited and admired by visitors, and therefore featured by postcard photographers. The first picture postcards date from around 1895–99, and the St Andrews postcards chosen here date from 1900 until the 1950s. They do not set out to be a comprehensive record of an older St Andrews, but have been chosen to indicate the flavour of it.

Not all postcards bought were written and posted, but rather bought and collected as mementoes of happy holidays and favourite places – in the same way that photographic views were bought and collected before the advent of postcards and the wide ownership of cameras. Between the death of Queen Victoria in 1901 and the beginning of the First World War, over ten billion postcards were posted in Britain.

A good postal service with frequent daily deliveries increased the popularity of the inexpensive postcard as a quick method of communication, and on occasion their use as a method of advertising. Colour photography was too expensive to use in the early days of postcards, and early coloured postcards were produced by hand-tinting monochrome images. Such postcards can be of great charm, although their colours are not always true to life. The reproduction of paintings also added colour to postcards.

Readers might be interested in the location of the main St Andrews post office during the period covered by this book. From 1892 to 1907 it was located in purpose-built South Street premises known later as The Christian Institute that is today incorporated into J. & G. Innes Ltd on the corner of South Street and Church Street. From 1907 to 2008 the post office occupied an adapted Victorian building at No. 127 South Street, and 2008 saw it move to within W. H. Smith in South Street.

St Andrews

St Andrews, 'the burgh of St Andrew', a historic European city, was founded sometime between 1144 and 1153 by Bishop Robert with royal permission, and the setting of the new burgh was a beautiful one. It overlooked St Andrews Bay with the Argus hills to the north,

and the Grampians in the far distance. The Bishop's burgh absorbed the much older Celtic religious settlement of Kinrimund/Kilrymont centred on the high ground at the Kirkhill above the harbour, and became in time one of the country's earliest and most prosperous burghs.

Saints, hermits and 'three virgin saints', it is said, brought the relics of the 'blessed Andrew' to where his city would be established. Those saintly relics ensured that St Andrews became one of the most important pilgrim cities in medieval Europe, the seat of Scotland's most important bishopric and the site of the country's largest cathedral, the now ruined great cathedral church of St Andrew, the focal point of medieval St Andrews.

Founded in 1160, it was consecrated in July 1318 in the presence of King Robert the Bruce, when thanks were also given for victory over the English at Bannockburn in June 1314. The shrine of St Andrew was at the east end of the cathedral, where its building had begun.

1472 saw the Bishop of St Andrews become Archbishop and Primate of Scotland, and until the Reformation (1559), St Andrews, with its Augustinian Priory, its episcopal palace, St Andrews Castle and its university founded in 1410–14 became the ecclesiastical capital of Scotland – an important, influential, cosmopolitan town with Scottish Royal and European connections.

In the troubled times after the Reformation, St Andrews gradually lost its importance, so much so that in 1697 the university's academic staff pressed for its removal to Perth. The town remained in recession until Victorian times saw its regeneration, expansion and promotion as a desirable residential town with elegant new houses and streets and a seaside resort and golfing town.

When the postcards were published, St Andrews was a quiet but growing residential, university and golfing town with a summer season. In 1914 its population was 7,000, its gas-lit streets supplemented by five electric street lamps. The population had increased to 9,987 by the 1930s, and by 1948–51 the university had more than 2,000 students. The postcard years were marked by the First World War and the Second World War.

Before the First World War many of the town's larger houses had resident domestic staff, and both coalmen making deliveries and message boys were a common sight. The Second World War saw some hotels and a number of large houses occupied by the military, while the West Sands was fortified against invasion with barbed wire and anti-tank blocks. Shops were concentrated in Market Street, South Street, Church Street (boasting a tinsmith) and Bell Street and, by the end of the 1940s, numbered around 226 which provided a variety of goods and services.

In the world of golf of the postcard days, St Andreans, as golf professionals, greenkeepers, golf course designers and teachers, promoted golf at home and abroad, while St Andrews-crafted golf clubs were in demand. 1921 saw St Andrews-born American Jock Hutchinson win the British Open Championship at St Andrews. Women's golf continued to grow in importance, as crowds of spectators watched Miss Grant-Suttie win the Ladies' Scottish Championship of 1911 at St Andrews. The first motorcycle races were held on the West Sands in 1909.

St Andrews Town Council began to build council houses for rent in the 1920s on 'greenfield' sites beyond the Kinness Burn – building began with Sloan Street (1922) and Lamond Drive (1925). 1934 saw 498 houses built, known as 'the new houses'.

Spring 1926 saw the revival, with the university's approval, of the student Kate Kennedy procession as an historical pageant of St Andrews and Scotland. 1881 had seen the procession banned as it was deemed too rowdy.

After a public meeting, St Andrews Preservation Trust was formed in 1937 'to preserve for the benefit of the public, the amenities and historic character of the City and Royal Burgh of St Andrews'. Support was promised by the National Trust for Scotland. The same year, in May, the first public performance took place in the first tiny Byre Theatre in Abbey Street.

St Andrews remained an active lifeboat station until 1938, its lifeboat crewed by St Andrews fishing families.

In closing this small window on an older St Andrews, I might mention that the 'postcard years' saw no new local-authority primary or secondary schools built beyond the Kinness Burn until Langlands Primary of 1954. The 1940s saw the town's first public library opening, in a converted shop in Church Square. It was a Fife County Branch Library (with children's books). It later relocated to Queen's Gardens.

St Andrews had a railway (1852–1969). Its station is now part of the Petheram Bridge car park. Until the outbreak of war in 1939, the horse-drawn hansom cabs, owned by William Johnston, No. 117 Market Street and Nos 104–108 North Street, met trains on their arrival and departure at St Andrews Station. The cabs added an unusual period touch to the St Andrews Streets, and were popular for university balls and dances.

In contrast the first St Andrew Civil Air Display took place at the West Sands in 1919, when passenger flights were available. The planes that took part were from Leuchars airbase.

The economy of modern St Andrews, with a population of around 17,000, is still based on its university with around 7,775 students, the tourist and conference industry and as the 'Home of Golf'.

Since the 1960s the town has grown greatly in size, and seen many changes. As a result of the Local Government (Scotland) Act, St Andrews lost its town council in 1975, and the North-East Fife District Council was set up. 'Greenfield' sites have been developed for private housing; primary schools have been built and shopping is no longer confined to the town centre, while 2009 saw the new NHS St Andrews Community Hospital opened in Largo Road. St Andrews today is a cosmopolitan town enriched with worldwide contacts through its golf, university, tourists and those who come from other continents to settle in the town. But there is a long-standing shortage of affordable, unfurnished housing and few families stay in the town centre.

ST ANDREWS

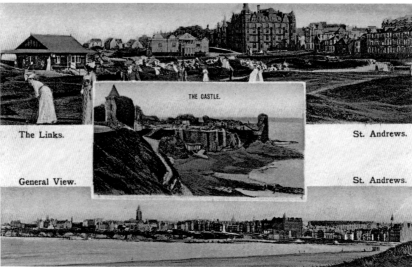

The Links.

THE CASTLE.

St. Andrews.

General View.

St. Andrews.

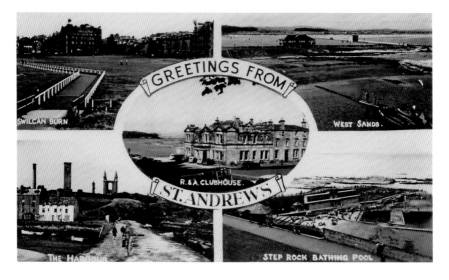

SWILCAN BURN

WEST SANDS.

GREETINGS FROM

R. & A. CLUBHOUSE.

ST ANDREWS

THE HARBOUR

STEP ROCK BATHING POOL

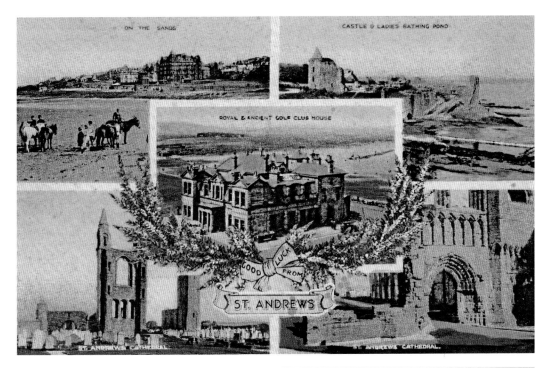

Multi-view Postcards of St Andrews
The one above dates from 1906. The
one on the right is more recent. Note
its mini view of the West Sands, which
features in the foreground and the beach
shelter built in 1926 and demolished
in 1989 for more parking space. The
small castellated building of 1930
in the background was built to deal
with sewage. It was locally known as
'Cantley's Castle', nicknamed for the then
town clerk and local lawyer.

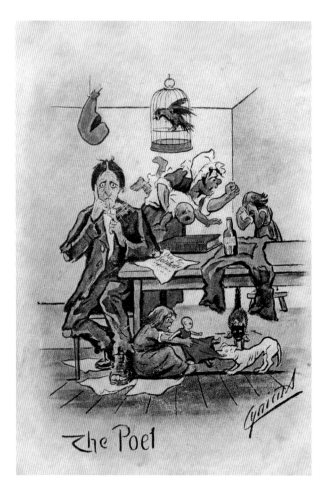

the Poet

Cards and More Cards!

Left: Not a happy home! A hand-tinted Cynicus (Martin Anderson) postcard belonging to the author, which was gifted to her. Published by the Cynicus Publishing Co. Ltd, Tayport, Fife, it was among the first picture postcards received by the family, who originally owned it in the early 1900s. It was pasted in the village of Ceres in Fife. Martin Anderson (1854–1932) was a pioneer of the comic postcard. He favoured simple bright colours in his artwork. He also produced sympathy and Christmas cards.

Below: a postcard of slightly later date, on which its sender wrote, 'Heavy snowstorm today. How do you like this view?'.

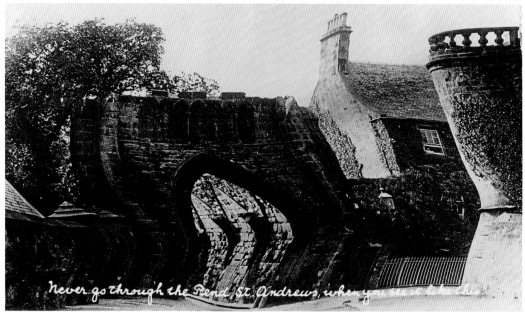

Never go through the Pend, St. Andrews, when you see it like this.

THE CASTLE &
THE CATHEDRAL

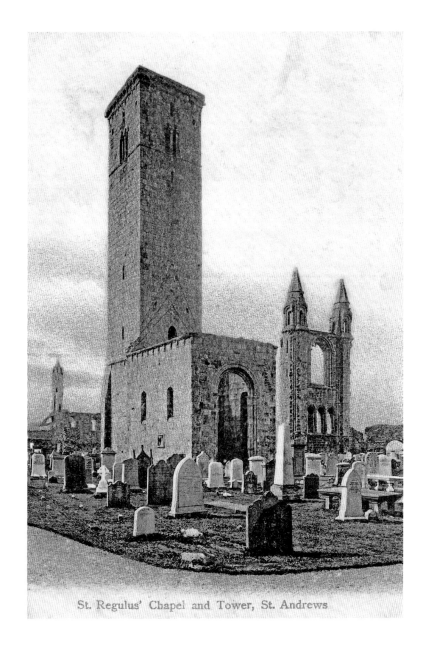

St. Regulus' Chapel and Tower, St. Andrews

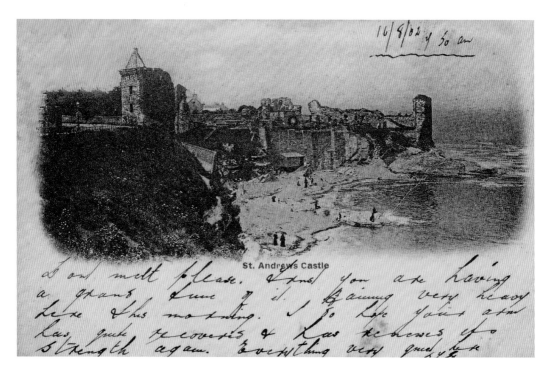

16/8/02 9 50 am

St. Andrews Castle

An 'Undivided Back' Postcard
Above, an 'undivided back' postcard of 1902; only the recipient's name and address could be written on the back of the card. Any message had to be written below the illustration. Here is a view of St Andrews Castle and the Castle Sands from the south-east. Note the changing facilities for lady bathers. The Earthy Brae is on the left. Below, the ladies bathing pool at the Castle Sands.

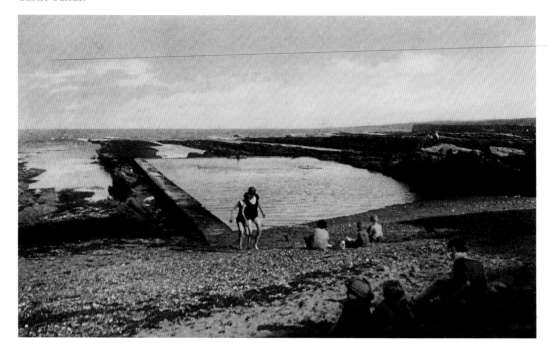

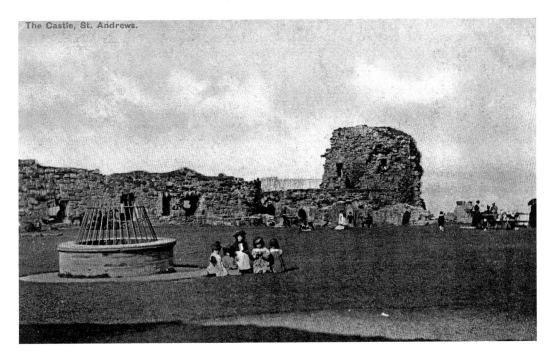

The Palace of the Bishops and Archbishops of St Andrews

St Andrews Castle and its courtyard, *c.* 1904. The card above looks south and shows the castle's fore tower, well and entrance. Two wings once flanked the fore tower; on the east was the chapel range with a then fashionable loggia – looking north. Persistent erosion of the cliff on which it stood caused the chapel range to fall into the sea. The view below looks to St Andrews Bay, and shows damage caused by French gunners during the 1547 siege of the castle, then held by Cardinal David Beaton's assassins.

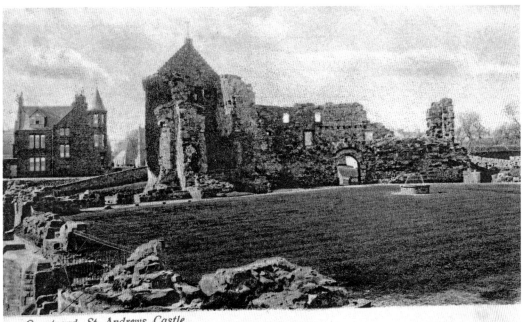

Courtyard, St. Andrews Castle.

13

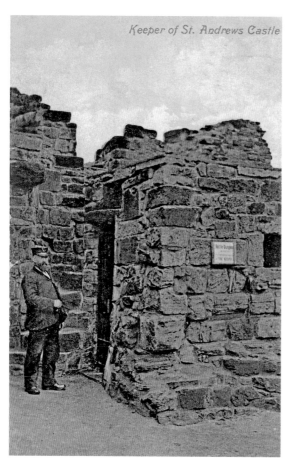

A Castle and its Dungeon
The Keeper of St Andrews Castle,
c. 1909. He stands outside its Sea
Tower which dates from 1385–1401.
In the tower is the entrance to the
castle's infamous Battle Dungeon. Dug
out of solid rock, this bottle-shaped
pit prison is 24 feet deep and around
15 feet wide at the bottom. Victorian
visitors were told prisoners were let
down into its depths from transverse
beams in the upper room. After his
1546 murder, Cardinal Beaton's body
was flung into the dungeon. Below
is the late sixteenth-century castle
frontage completed by Archbishop
John Hamilton. The brae (slope) on
the right leads down to Castle Sands.

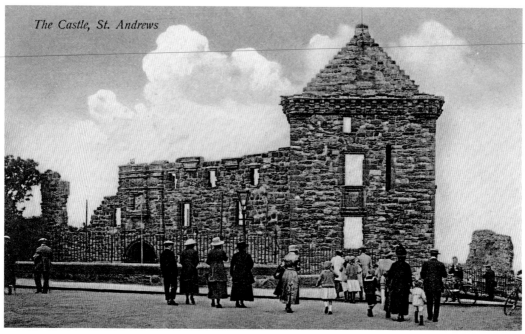

The Castle, St. Andrews

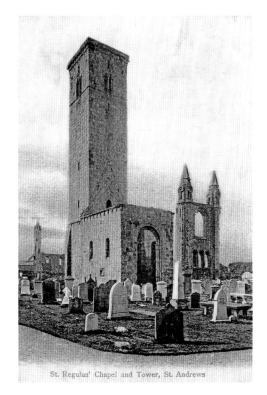

St. Regulus' Chapel and Tower, St. Andrews

Views of Two Towers

The early twelfth-century St Regulus'
Chapel and Tower, or St Rule's Church and
Tower (the Square Tower), *c.* 1906, was
the first church of the Augustinian Priory
and forerunner to the Cathedral Church of
St Andrew, founded in 1160 and standing
within the cathedral precinct. It housed
the relics of the 'blessed Andrew' until the
cathedral was built. The Haunted Tower is
one of the thirteen fortified towers of the
cathedral precinct wall. Opened in 1868, it
was found to contain mummified bodies, one
a dark-haired girl. Possibly the tower was a
family mausoleum; when opened again in
1888 the bodies had vanished.

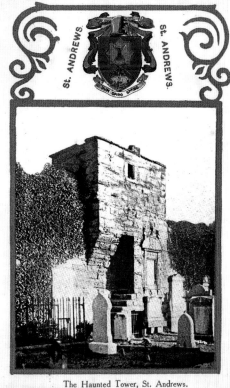

The Haunted Tower, St. Andrews.

15

ALONG THE SEAFRONT

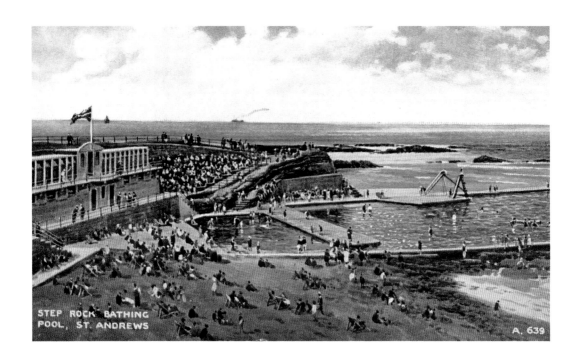

STEP ROCK BATHING POOL, ST. ANDREWS

A. 639

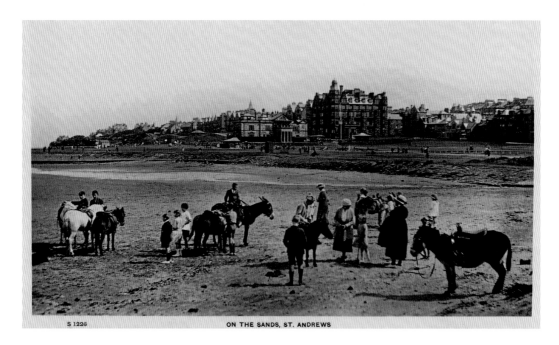

S 1226 ON THE SANDS, ST. ANDREWS

St Andrews Beach Donkeys

Donkeys disappeared from the West Sands around 1977. On the Monday and Tuesday of the Lammas Market, the beach donkeys came to town and gave rides in Queen's Gardens, where itinerant photographers would snap the donkeys and their riders.

Having Fun by the Sea. XT.23

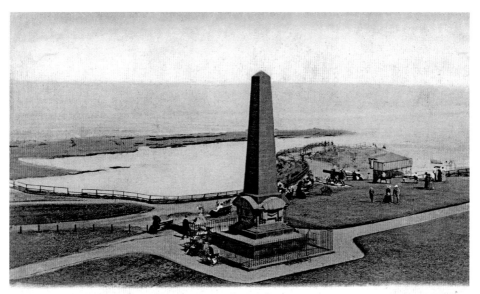

Martyrs' Monument and Bathing Station. St. Andrews.

A Monument, a Bathing Station and a Bandstand

Martyrs' Monument of 1842 features in both views. Above, the Step Rock Bathing Station beside the cannon was for men and boys only, and was replaced by the Step Rock Bathing Pool (1902–03), where mixed bathing was not allowed until 1929. Sea erosion caused the C-shaped bay in the background; 1911 saw its reclamation and it became the site of the St Andrews Beach Pavilion in 1927. Below is the Bow Butts bandstand erected by St Andrews Town Council in 1905. It was made by Walter MacFarlane's Saracen Foundry in Glasgow, famous for its ornamental ironwork. During the summer it is still in use. A still-remembered black cannon was once sited overlooking the Bow Butts. The Scores was developed in the nineteenth century.

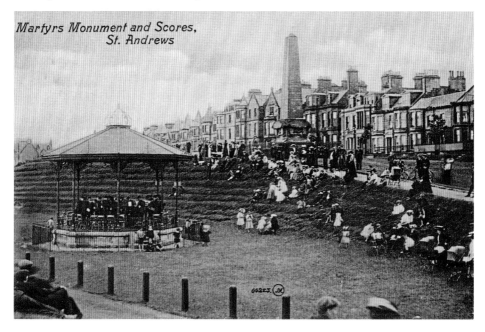

Martyrs Monument and Scores, St. Andrews

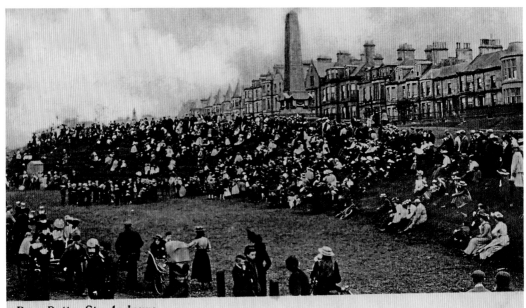

Bow Butts, St. Andrews.

Listening to the Band
Listening to summer music at the Bow Butts before the bandstand was erected in 1905.

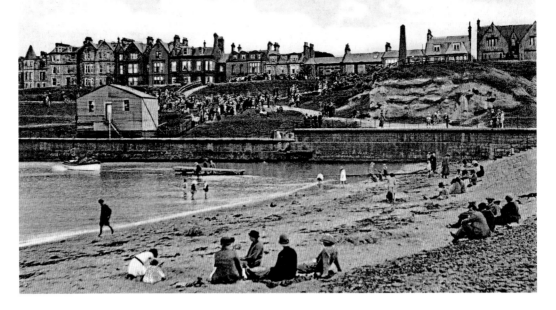

The Seaside and Braes, St. Andrews

Where We Staged Our Shows

'The seaside and Braes St Andrews' features the Pierrot Pavilion (centre left) that was destroyed by fire in November 1926. Note the jetty and boat. Summer trips to view St Andrews from the sea were popular. Below, the old Pierrot Pavilion was replaced in 1927 by the St Andrews Beach Pavilion, where the Pierrots staged their seaside variety shows until the 1950s when the Pavilion's terraced seating, open to wind and weather, decided the Pierrots to move to the town hall. A collection box was always taken round to nudge the non-paying standing audience. The 1927 Pierrot Pavilion is now incorporated into the Seafood Restaurant, but prior to this it is remembered as the seasonal Pavilion Tearoom, still in business in the 1990s.

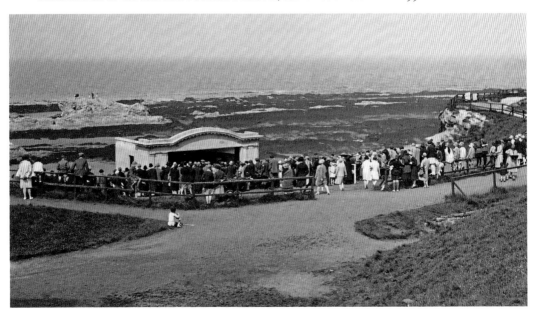

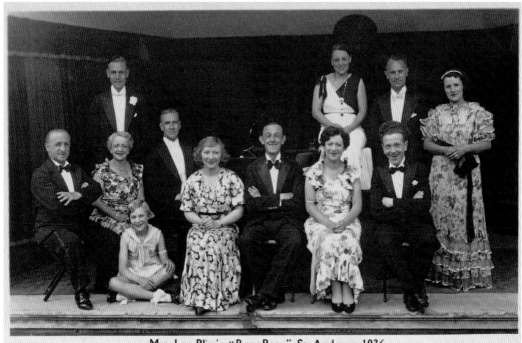

Mrs. Leo Bliss's "Busy Bees." St. Andrews 1936.

You Would Have Enjoyed Our Show!
Pierrots were once popular seaside entertainment. Two advertising postcards for St Andrews' Pierrots, the one above dates from 1910–14 and the other promotes the 'Busy Bees' of 1936. Summer Pierrot shows continued to be staged in the St Andrews Beach Pavilion during the Second World War. When in spite of wartime restrictions, barbed wire, rationing and air raids, St Andrews remained a popular holiday resort.

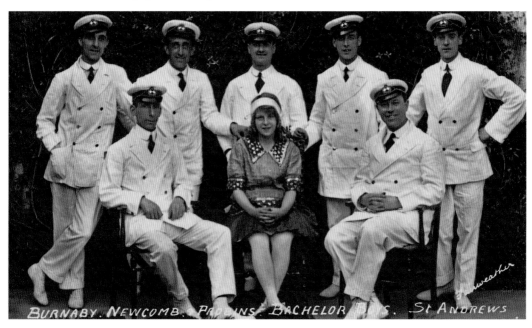

BURNABY. NEWCOMB. PROBINS BACHELOR PLAS. St ANDREWS

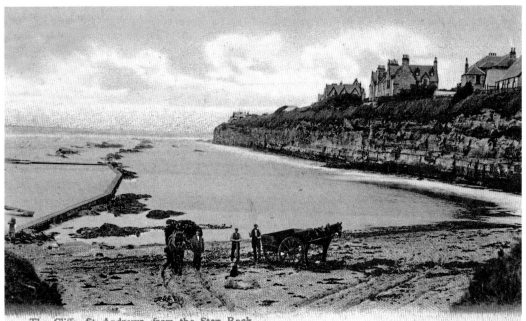

The Cliffs, St. Andrews, from the Step Rock

Seaweed and Sand
Here seaweed and other debris left behind by winter storms is being cleared from the Step Rock Sands in preparation for a new holiday season. The seaweed was valued as fertiliser. The Step Rock Swimming Pool is on the left. Below, in the foreground, children play in the Swilcan Burn as it enters the sea at the West Sands. No casual beachwear for adults or children then.

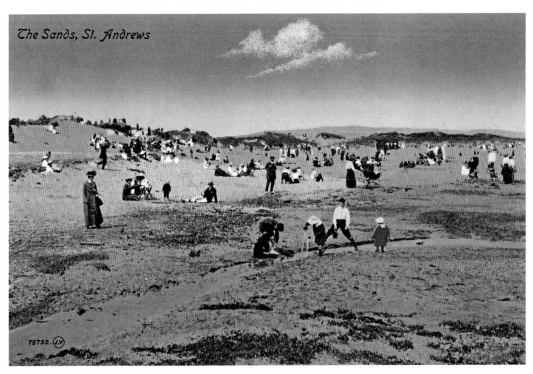

The Sands, St. Andrews

75752. J.V

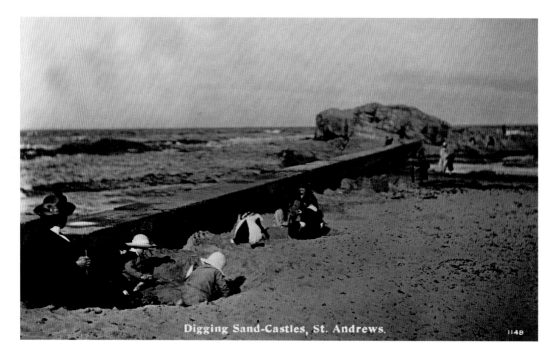

Digging Sand-Castles, St. Andrews.

1148

Sand and Sun

Here the children are building sandcastles on the sand between the Step Rock and the West Sands, beside the breakwater built by the town council to protect the area from erosion by the sea, from which it was reclaimed as of 1893 onward. Common to both views is the Dhu Craig Rock, with its tidal sea pools alive with sea life, and the curious Elephant Rock worn by time and tide.

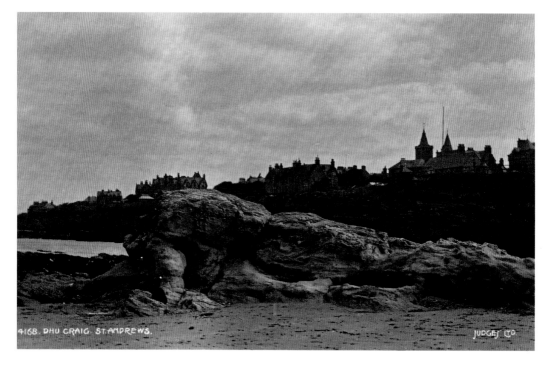

4168. DHU CRAIG. ST. ANDREWS.

JUDGES LTD.

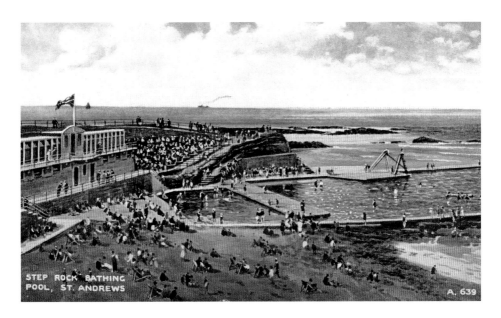

STEP ROCK BATHING POOL, ST. ANDREWS

A. 639

I Do Love to be Beside the Sea!

The Step Rock Bathing Pool was in use as a tidal seawater swimming pool from 1902, until it was replaced by an indoor swimming pool at the East Sands Leisure Centre of 1988. The years 1972–73 saw the pool shortened and repaired. Once summer for holidaymakers and St Andreans alike, the height of the Step Rock's popularity was in the 1930s, 1940s and 1950s. It was still popular in 1960s, but holiday tastes and expectations were changing. With the pool more than 7 feet deep in the area of the diving board and chute, the pool's gradual entry was a popular feature, as was the children's paddling pool (below). Part of the Step Rock experience were the trays of tea and coffee available from its kiosk, in company with spades and pails, ice-cream and sweets, deck-chairs and postcards, while swimming galas, water polo, diving and lifesaving displays were promoted by the Step Rock Swimming Club that was founded in 1928.

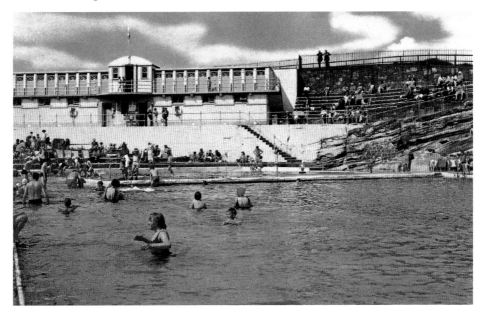

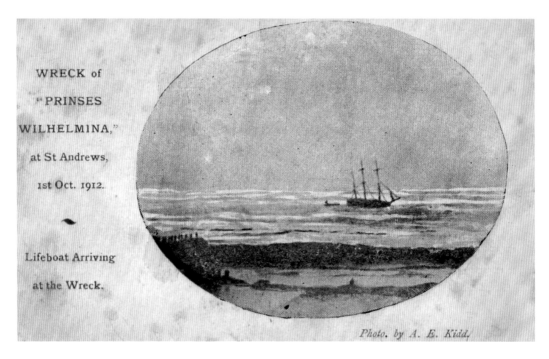

WRECK of "PRINSES WILHELMINA," at St Andrews, 1st Oct. 1912.

Lifeboat Arriving at the Wreck.

Photo. by A. E. Kidd.

The Wreck of the Prinses Wilhelmina

The St Andrews lifeboat, the *John and Sarah Hatfield*, rescuing the crew of nine of the 366-ton *Prinses Wilhelmina* of Halmstad, Sweden. She was wrecked on 30 September 1912 below St Andrews Castle in a north-easterly gale, while making for Dundee with a cargo of firewood. She later drifted on to the West Sands where the ship's cat was found alive and well. The barque's wreck attracted numerous sightseers, photographers and artists. The *John and Sarah Hatfield* (powered by oars and sail) was the last of the St Andrews lifeboats. The town ceased to be a lifeboat station in 1938.

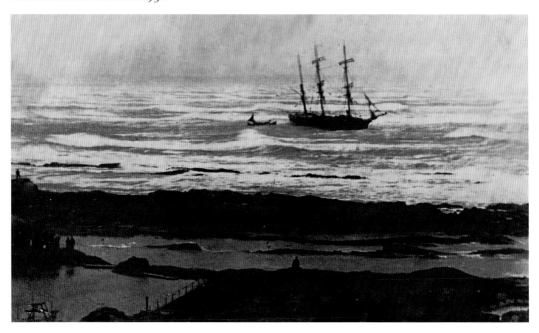

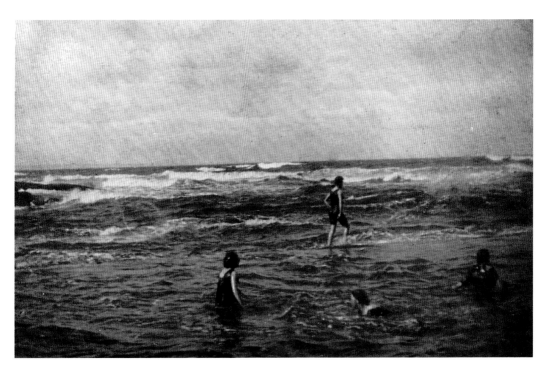

Breakers!
Braving the breakers in 1907 at the Castle Sands, where there were facilities for lady bathers and a female attendant. Bathing dresses and towels were also hired out. Otherwise ladies bathed on the West Sands, or used private The Baths near the castle. Below, high tide on the West Sands.

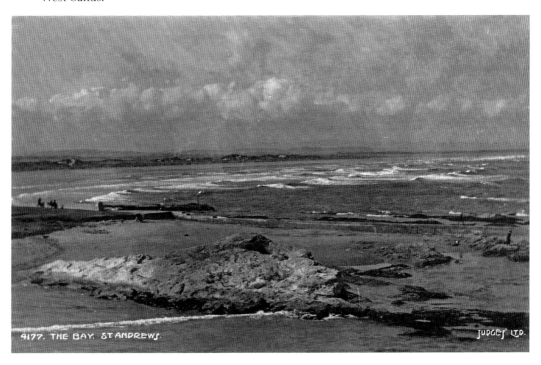

9177. THE BAY. ST ANDREWS. JUDGES LTD.

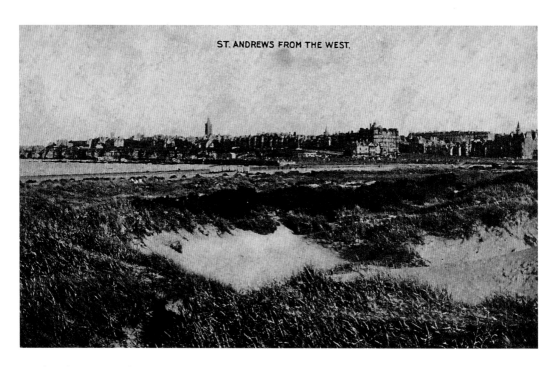

ST. ANDREWS FROM THE WEST.

Sand and More Sand
'St Andrews from the West' shows the sand dunes that were and are a feature of the West Sands.

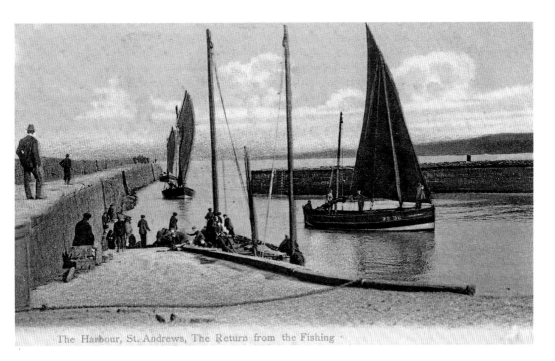

The Harbour, St. Andrews, The Return from the Fishing

The Fishing at St Andrews

Fishing yawls entering the harbour, *c.* 1909. Left is the historic Long Pier or North Pier (lengthened in 1900) and right is the seventeenth- or eighteenth-century cross pier. A tidal harbour, one of the oldest in Scotland, it was described in 1222 as a fishing harbour. Today it is a category A-listed building used by local fishermen and boat owners. Below, a forest of masts and a crowd of people show a busy working harbour. Then St Andrews was the home port for both inshore and deep-sea fishing boats. The latter leaves St Andrews for distant waters to take part in the seasonal haddock and herring fishing. St Andrews Bay lobsters were also in demand, as they are today.

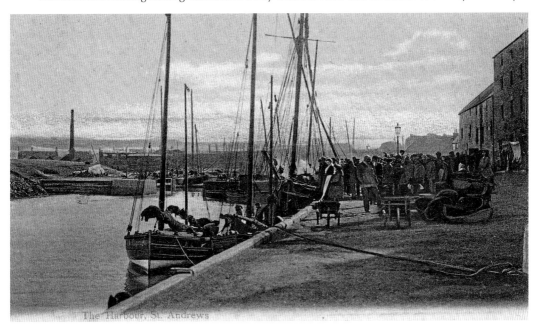

The Harbour, St. Andrews

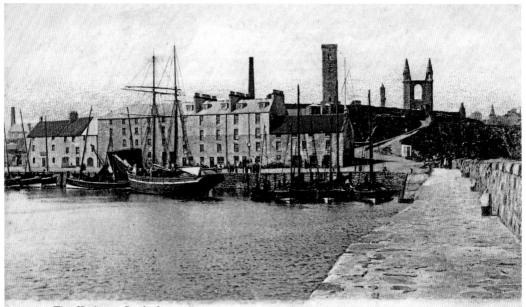

The Harbour, St. Andrews

P.S. You must come & spend the week end with us soon. We'll be back on T

The Harbour

Views of the Shorehead and the harbour, *c.* 1910. Above, the pantiled fisherpub, the Bell Rock Tavern, stood at the north end of the Shorehead at the foot of the harbour brae. In an earlier life it had been a tanner's loft with cellars and store. Centre is the Royal George fisher tenement, with the gasworks chimney behind. Note the building line on the Royal George which indicates the alterations made to the original warehouse by George Bruce. Below, a quiet inner harbour with the three-storey Auld Hoose public house left of centre.

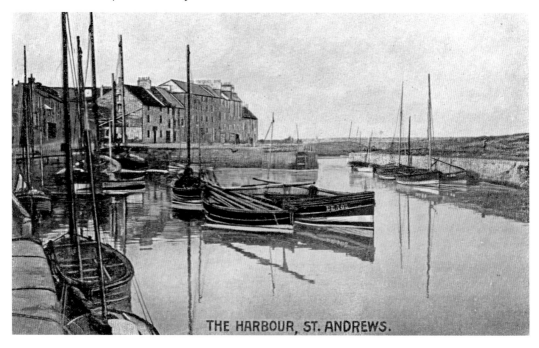

THE HARBOUR, ST. ANDREWS.

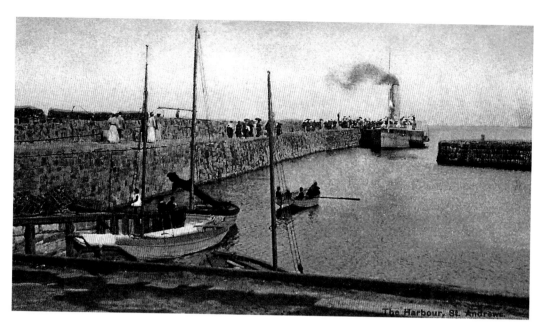

A Summer and Winter Harbour

An attractive summery view. All aboard! a steamer at the St Andrews Long Pier. Pleasure excursions in boats were very popular. Below, a wintry harbour with a few fishing yawls in the inner harbor, a vintage view which shows the back of some of the Shorehead buildings, photographed from the Gas Works Brae. The end building on the left is The Auld Hoose pub; its neighbours include the coastguard's office and store. There is (right) a glimpse of the now demolished gasworks. Gas was made here from 1835 to February 1962. Part of today's Kirkheugh Cottage is on the extreme left. In the distance are the Kinkell Braes and, far right, part of the cathedral precinct wall.

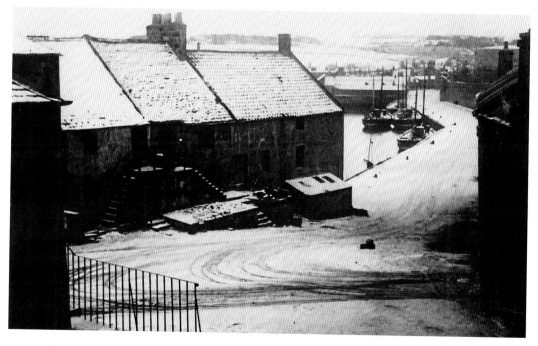

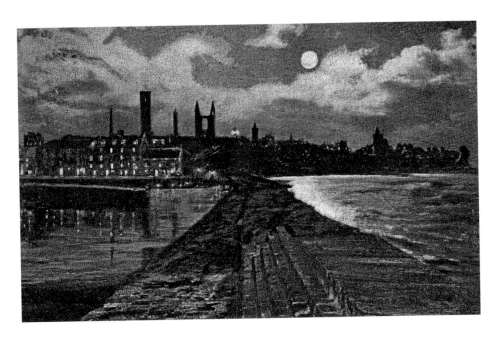

An Overcrowded Tenement

A brightly lit Royal George, *c.* 1904, named after the RNS *Royal George* that sank at Spithead in August 1782, crowded with crew and visiting families. A warehouse converted in around 1869 by the local developer George Bruce, the tenement provided around twenty rooms and kitchen homes with box beds. Stairs and balconies provided access to the upper flats at the rear of the building. Only a narrow roadway separated the Royal George from the gasworks. Condemned, it was cleared of tenants in 1935. 1964 saw the gasworks demolished and the Royal George, with neighbouring buildings, was redeveloped as private housing

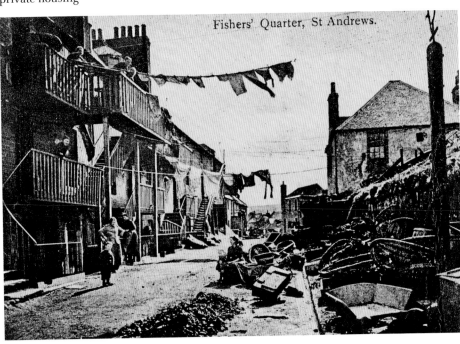

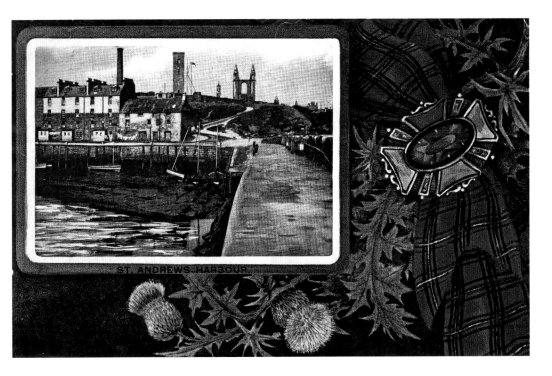

ST ANDREWS HARBOUR

Harbour and Castle
A quiet early morning harbour and a quiet moment in the working day. The erosion by time and tide of the cliffs seen here has been remedied. St Andrews Castle, the Episcopal Palace of the Bishops and Archbishops of St Andrews, was one of the most important strongpoints of Scottish kingdom, and had a stormy history.

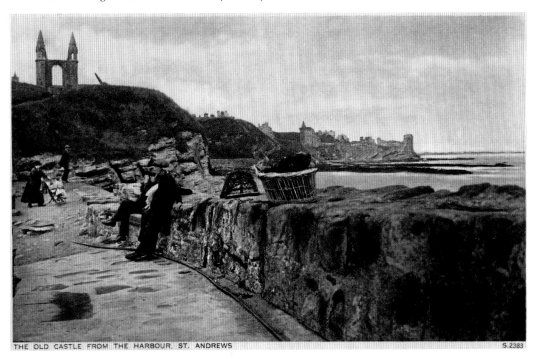

THE OLD CASTLE FROM THE HARBOUR, ST. ANDREWS S.2383

SOUTH STREET

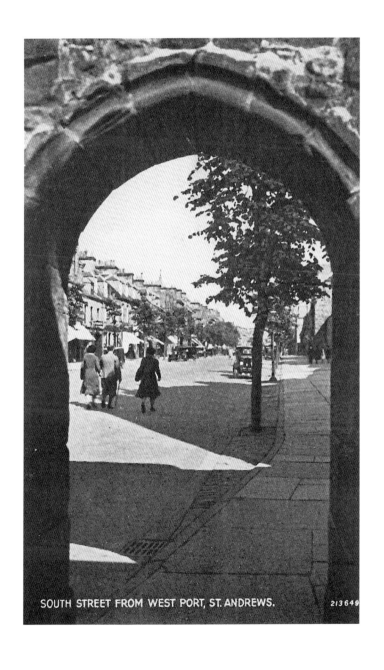

SOUTH STREET FROM WEST PORT, ST. ANDREWS. 213649

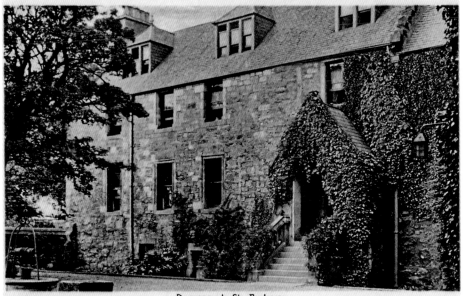

Deanscourt, St. Andrews.

Deanscourt

Views of Deanscourt near the cathedral, The Pends, and Priorsgate, a later extension of 'Queen Mary's House'. Before the Reformation, Deanscourt (now a university property) was the Archdeacon's Manse. Reconstructed around 1570 by Sir George Douglas, it has a walled garden, well, and a gated entrance with Sir George's (d. 1606) arms. Handsome Sir George – 'Pretty Geordie' – and young Wellie Douglas helped Mary, Queen of Scots escape from Loch Leven Castle in 1568. Below, the fourteenth-century 'The Pends', the principal entrance to the cathedral precinct from the town, with part of Priorsgate (right) and 1 South Street, 'The Roundel', with its balustraded parapet.

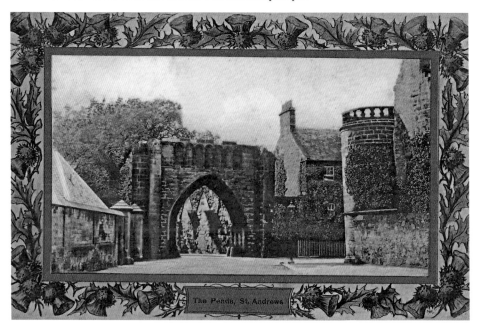

The Pends, St. Andrews.

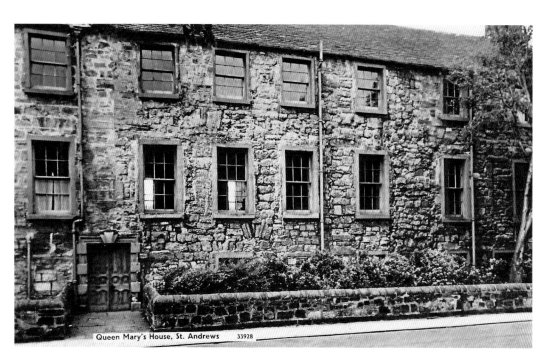

Queen Mary's House, St. Andrews 33928

Queen Mary's House
A view of the South Street plain frontage of Queen Mary's House that contrasts with the postcards on the next page.

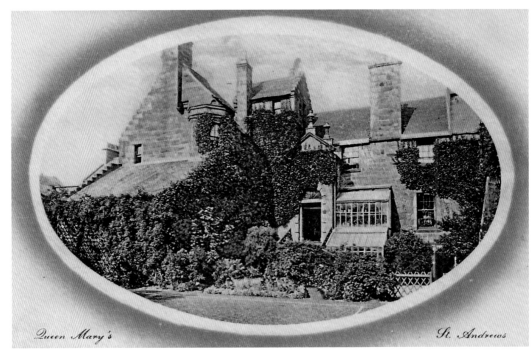

Queen Mary's St. Andrews

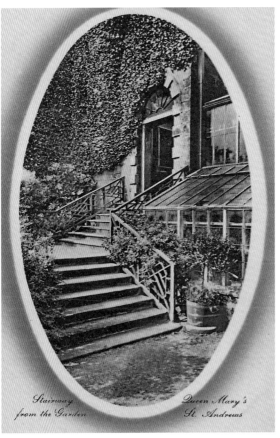

Stairway from the Garden Queen Mary's St. Andrews

Queen Mary's House
Views of the south-facing decorative garden frontage of 'Queen Mary's House'. It stands at the east end of South Street near the cathedral and 'The Pends'. The St Andrews merchant Hew Scrymgeour began building it in 1523. It is so named, because Mary, Queen of Scots, holidaying in the burgh in 1564, occupied a suite of rooms in it. She is traditionally associated with the corner oriel, seen here wreathed in greenery. The house would have been well known to Sir George Douglas. It was renovated in 1927 as a library for Sir Leonard's School.

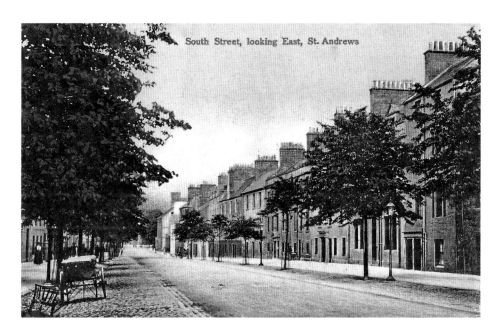

South Street, looking East, St. Andrews

Publishers of Early St Andrews Postcards

'South Street, looking East' was published by George L. Fleming. One of the early postcards he published from his small, double-windowed newspaper shop at No. 45 South Street, which was sited near the cart in the view. On the right of 'South Street, St Andrews,' looking to the East Port, the striped awnings indicate the position of Fletcher's, No. 121 South Street, which closed in 1983. Fletcher's sold quality fancy goods, stationery, books ... and were publishers of early St Andrews postcards. Early postcards were also sold and published by J. & G. Innes, The Citizen Office, stationers and booksellers, No. 107 South Street.

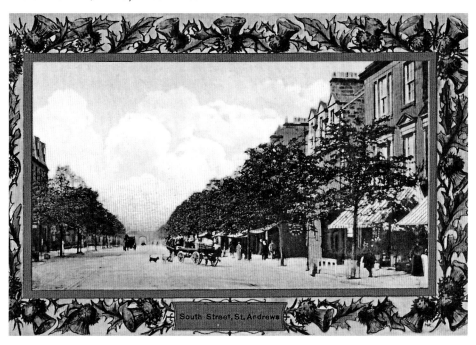

South Street, St. Andrews

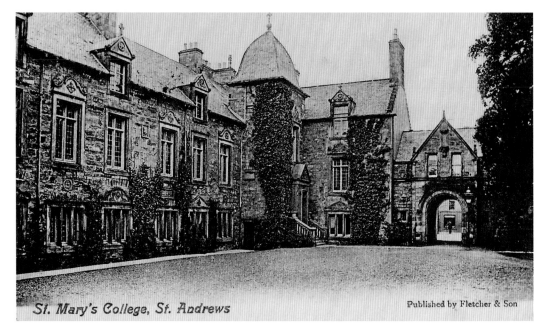

St. Mary's College, St. Andrews

Published by Fletcher & Son

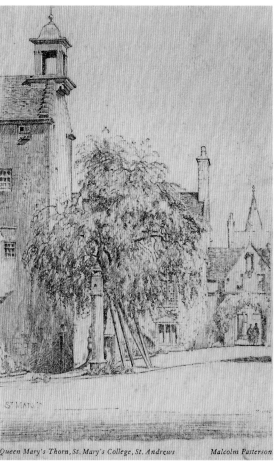

Queen Mary's Thorn, St. Mary's College, St. Andrews Malcolm Patterson

St Mary's College, the University of St Andrews

Views of St Mary's College in South Street. The photograph dates from 1909; the drawing by Malcolm Patterson from 1926. Built on the site of the old 'A Pedagogy' of 1430, the college was founded in 1537 and was completed in 1554 by Archbishop John Hamilton, whose arms are over the entry to the bell tower. Queen Mary's thorn is believed to have been planted by Mary, Queen of Scots. The foliage seen on the right of the photographic view belongs to the college's eighteenth-century holm oak. Malcolm Patterson (1873–1941) was a widely exhibited artist at home and abroad. He taught art at St Leonard's School.

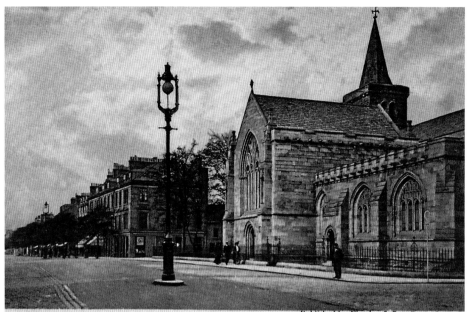

Church of the Holy Trinity and South Street, St. Andrews

Published by Fletcher & Son, St. Andrews
J. V.

An Historic Parish Church

Views of the church of the Holy Trinity – 'The Town Kirk' in South Street – founded by Henry Wardlaw, Bishop of St Andrews (1403–40). Trinity Church is clearly marked on a 1642 Plan of St Andrews. Wardlaw's parish church replaced an earlier one near the Cathedral (1798–1800) which saw the town church undergo major alterations (excluding its tower and steeple) when it became a galleried church. It was restored as near as possible to its medieval form (1907–09).

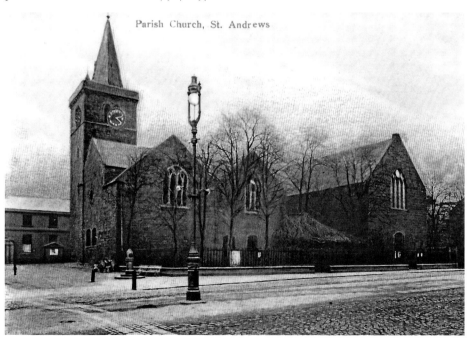

Parish Church, St. Andrews

The Path through the Wood, Magus Muir

Geo. L. Fleming, 45 South St., St. Andrews.

A Murder and a Marble Tomb
On 3 May 1679, on Magus Moor near St Andrews, Dr James Sharp, Archbishop of St Andrews, Primate of all Scotland, Royal Chaplain to Charles II, was dragged from his coach by a band of Covenanters and murdered. His St Andrews funeral took place on 17 May 1679, and included his coach. His marble tomb is in Holy Trinity Church. Kinkell Braes stones were used for the cairn which marked the spot of his murder.

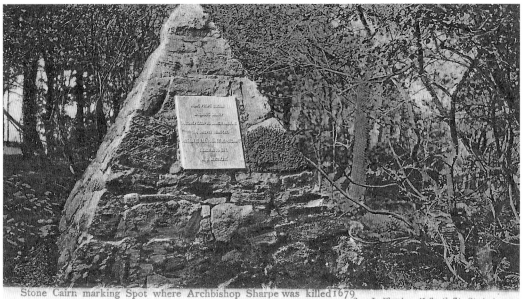

Stone Cairn marking Spot where Archbishop Sharpe was killed 1679

Geo. L. Fleming, 45 South St., St. Andrews

A Town Hall and a Bank

Above, 'South Street looking West' features the Bank of Scotland of 1871. Demolished in 1960, it was replaced by today's Bank of Scotland, built in a different style on the same site, the corner of South Street and Queen's Gardens. Below is the view from Holy Trinity Church Tower (looking south) down Queen's Gardens. On the right is the Bank of Scotland, and on the left the Town Hall, built 1858–60. The Town Hall incorporated a police station, entered from Queen's Gardens, which was in use until 1935 when a new police station (now closed) was opened in North Street. For a period after the Second World War the former Queen's Gardens police station served as a branch of Fife County Library, its former cells unseen by borrowers although still in position.

View from Town Church Tower (Looking South), St. Andrews

Geo. L. Fleming, 45 South St., St. Andrews.

43

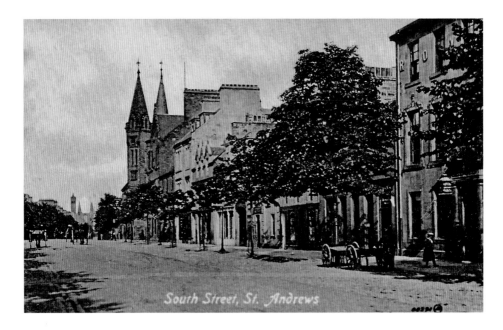

South Street, St. Andrews

A Hotel and a Café

Above, a view of a tranquil South Street looking east to the cathedral. The Victorian Royal Hotel (the cab is featured below) also had a horse-drawn omnibus and stabling for the convenience of its guests. In time Brown's Bakery became the small baker's shop which fronted the popular MacArthur's Café of 1933 (No. 116 South Street) with a large expanse of glass to the south, a tea garden and an open fire in the winter. The café hosted many local events. John W. MacArthur's main shop and bakery were sited at No. 34 South Street, where there had been a bakery since the fifteenth century. In 1865, at No. 34 South Street, John Paterson baked brown and fancy breads. The Royal Hotel is now the private housing complex, Southgait Hall and Court, while all the MacArthur property has been redeveloped except No. 34 South Street, which remains a retail outlet but not a baker's shop. The former attached bakery is now housing. The spires of the Town Hall and the Bank of Scotland are common to both views.

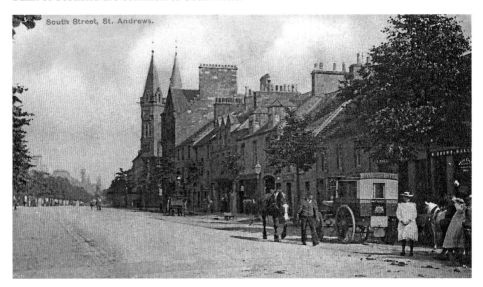

South Street, St. Andrews.

More South Street Postcards
Above, a view of the Burgher Close, No. 141 South Street, a fascinating piece of old St Andrews. This pantiled, three-storey, eighteenth-century building, with its masonic porch and fore stair, was acquired by St Andrews Preservation Trust from its long-term owners the Bell family. Its restoration by the trust was completed in 1963. Between 1774 and 1786 it was used as a Burgher Kirk meeting place. Today it is the location of small business outlets, and keeps its cobbled entrance. Below, a view of South Street in 1935. The sender wrote 'the main street of St Andrews ... a very charming place'. On the extreme left of the postcard is the Victorian building that was the main St Andrews post office from 1907 to 2008). On the right are the spires of the Town Hall of (1858–61), and the spire of the Bank of Scotland 1871.

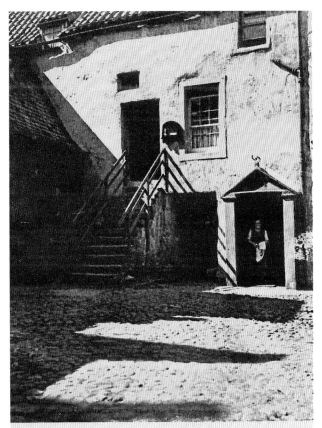

BURGHER CLOSE *Photograph by Gordon Bottomley*

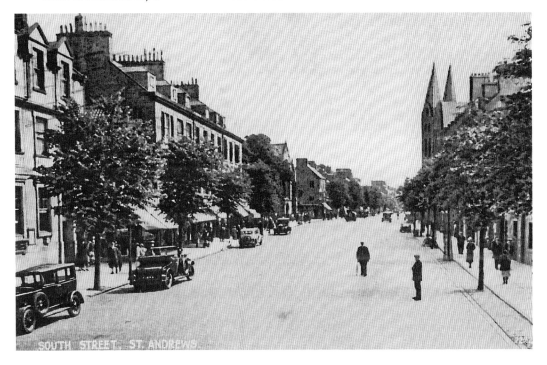

SOUTH STREET, ST. ANDREWS

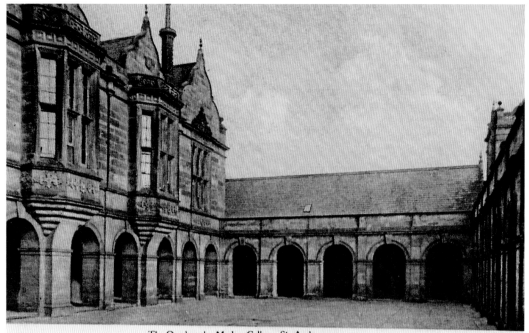

The Quadrangle, Madras College, S^t. Andrews.

A Landmark Building in South Street

Madras College was founded in 1832 by the St Andrews-born educational reformer the Revd Dr Andrew Bell (1753–1832) who promoted his own Madras, or monitorial, teaching system. Built of local sandstone, the co-educational school incorporated the town's Grammar School (boys only) and the English School, and was built in the grounds and gardens that once belonged to the St Andrews house of the Blackfriars or Dominicans. The arches of the school's quadrangle, 'The Quad', were bricked up to shelter pupils and staff during the air raids of the Second World War.

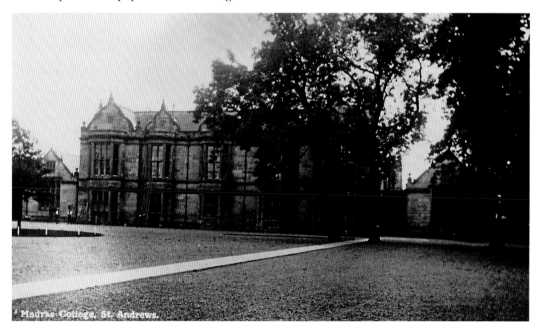

Madras College, St Andrews.

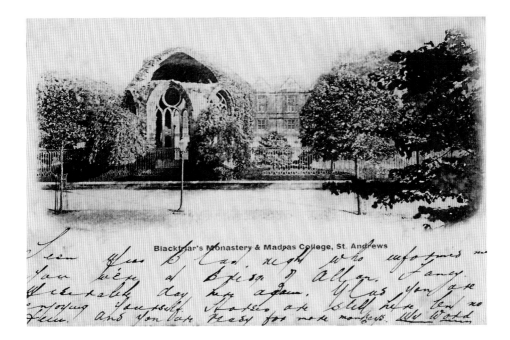

Blackfriar's Monastery & Madpas College, St. Andrews

A Little Bit of Postcard History

Same subject views, but each is different from the other. Unlike the card below, the back of the one above of 1902 was only for the recipient's name and address. Any message was written in the space below the view. 1902, however, saw the first postcards with divided backs for both address and message, as in the card below. The first line trees were planted on the south side of South Street in 1880. Today there are no trees in front of Madras College, as this is a stopping place for buses. The railings were removed from scrap during the Second World War, and not replaced. All that remains of the house of the Black Friars is the north transept of their church of 1525, whose vault is the only large medieval example left in St Andrews.

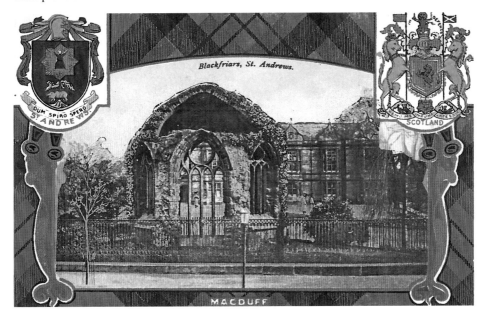

Blackfriars, St. Andrews.

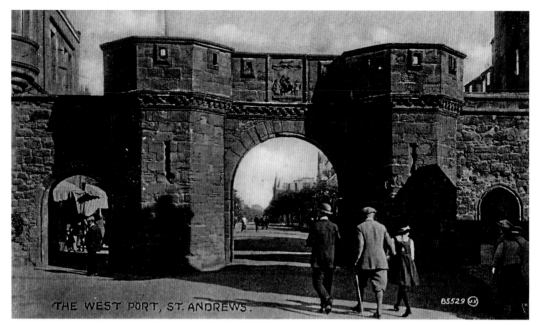

THE WEST PORT, ST. ANDREWS.

B5529

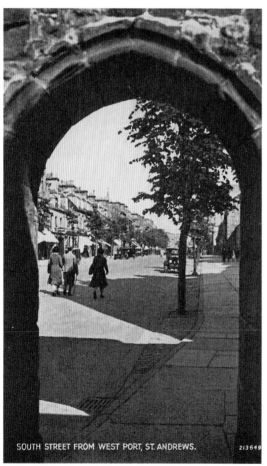

SOUTH STREET FROM WEST PORT, ST. ANDREWS. 213649

Sunshine and Old Stone
This 1929 postcard of the West Port
was photographed and published by
Thomas Howie, who owned a toyshop
at No. 4 Bell Street. Note the schoolgirl's
old-style gym tunic. The west Port,
that is the Southgait Port, once the
principal entrance to St Andrews, is the
only surviving St Andrews town port.
It appears on a 1642 plan of St Andrews
as the Southgate Port and was built in
the style of Edinburgh's Netherbow Port.
The period 1843–45 saw the renovation
of the West Port when side arches were
first inserted, and 'elegant and powerful'
buttresses replaced its old guard houses.
Right: the view of South Street from the
archway is from the 1930s.

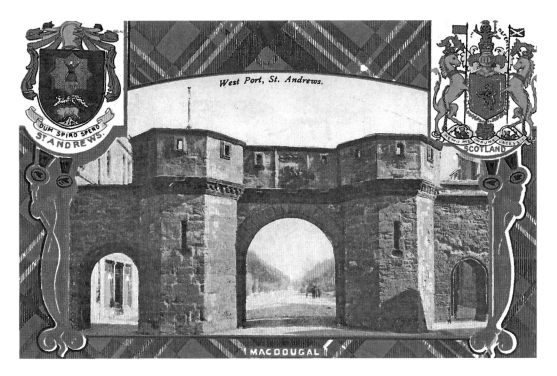

Looking East from the West Port along South Street
Looking east from the West Port along South Street, with the coats of arms of St Andrews and Scotland, *c.* 1907.

NORTH STREET

Kennedy's Tomb, College Church, St. Andrews

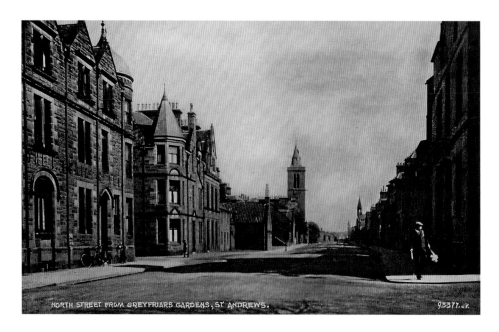

NORTH STREET FROM GREYFRIARS GARDENS, ST ANDREWS. 95377.JV.

A Picture House, a Hotel and a Café

On the far right of 'North Street from Greyfriars Gardens', the graceful spire of John Miller's Martyrs Free Church of 1852 (rebuilt in 1928 and now a university research facility) punctuates the sky. Note 'Gardens' should read Garden. Greyfriars Garden was developed from 1835 to 1844 on the pre-Reformation garden ground of the burgh's Franciscan Friary, whose well is still in existence. Greyfriars Garden's earlier name was North Bell Street, in honour of the founder of Madras College. Common to both views is St Salvator's College Tower, and the Imperial Hotel built 1879–81. The Second World War saw the creation of The Imperial with its 1920s' ballroom used for military purposes. The family-run Tudor Café was popular for Sunday lunches and teas, when few tearooms opened on a Sunday. The pantiled New Picture House, with its 936 seats and café, opened in December 1930. Today it is one of Scotland's oldest independent cinemas.

NORTH STREET, ST.ANDREWS D 1722

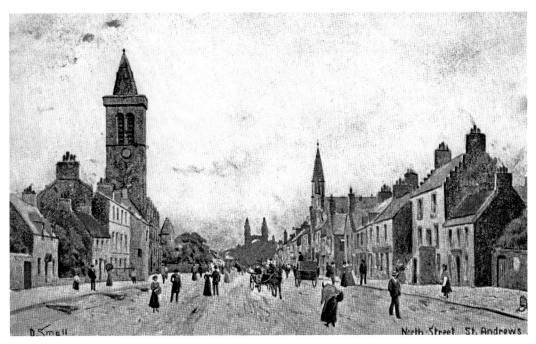

Cynicus Postcards

'North Street, St Andrews' and 'The Abbey' were published by the Cynicus Publishing Co., Tayport. Above, this postcard of North Street looks east. The tall property with the outside stair, with its smaller neighbours on the west, were replaced by one of the earliest Scottish picture houses, the now-demolished 808-seat Cinema House of 1913–79, presently the site of Muttoes Court built in 1983–84. Cynicus Martin Anderson (1854–1932), a former pupil of Madras College, artist and cartoonist, was a very early publisher of mostly comic postcards based on his own cartoons. Annie, his sister, supplied hand-coloured plates. The *Dundee Advertiser* was the first British daily to employ an artist to provide a newspaper with illustrations, and the paper's first artist was Martin Anderson.

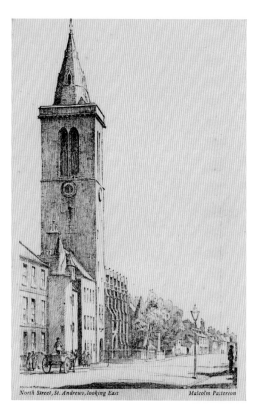

North Street, St. Andrews, looking East Malcolm Patterson

St Salvator's College

Malcolm Patterson's 1926 drawing looks east
and shows the North Street frontage of the
university's St Salvator's College, founded
by Bishop James Kennedy in 1450. East of
the College Tower is the College Chapel,
the Collegiate Church containing Bishop
Kennedy's tomb. Bishop Kennedy owned a
500-ton ship, 'a very fine vessel', *The Salvator*.

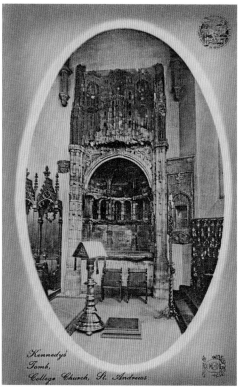

Kennedys
Tomb,
College Church, St. Andrews

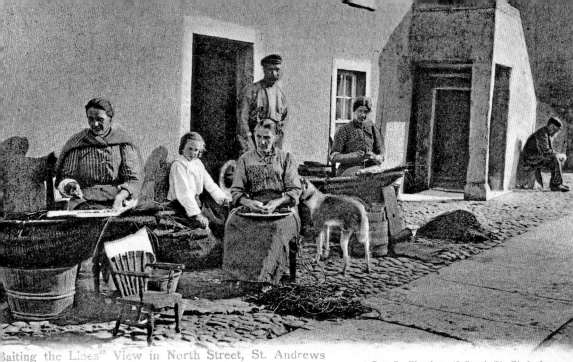

"Baiting the Lines" View in North Street, St. Andrews

Geo. L. Fleming, 45 South St., St. Andrews.

The Ladyhead Fisher Homes

Nos 19–23 North Street in the Ladyhead, the town's old fishing quarter, at the east end of North Street. Here lines are being baited with mussels from the River Eden. Nos 19–23 escaped demolition and were renovated in 1949 as one house. Its forestair is the only pillared one left in St Andrews. Below, Ladyhead fisher homes were demolished in March 1937 to provide a site for the rectory of All Saints Church. Once home to around 200 fisher families, the Ladyhead featured in some of the earliest St Andrews photographs (calotypes) when St Andrews was a centre for experimental photography in the 1840s.

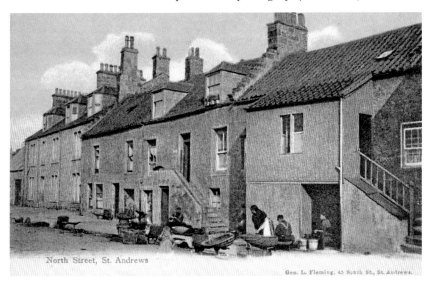

North Street, St. Andrews

Geo. L. Fleming, 45 South St., St. Andrews.

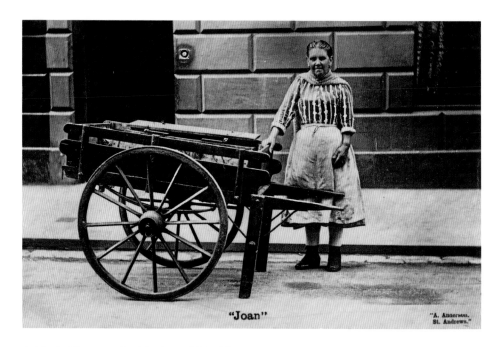

"Joan"

"A. Anderson, St. Andrews."

A Much Photographed Lady and Her Tiny House

Mrs Henry Waters Clark – 'Joan the fish wife' – with her fish barrow and her small picturesque house in South Castle Street, part of the old fishing quarter. 'Jo-ann', who was a member of a St Andrews' fishing family, was skilled at baiting the lines. She died in 1927, said to be the last of the St Andrews fishwives and the first to wear practical shorter skirts. Note her practical button boots, and her white stockings. 1966 saw 'Joan's House', and the neighbouring eighteenth-century house, each with a traditional forestair, restored as one property.

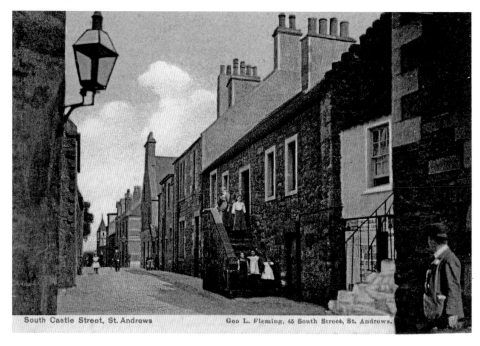

South Castle Street, St. Andrews

Geo L. Fleming, 45 South Street, St. Andrews.

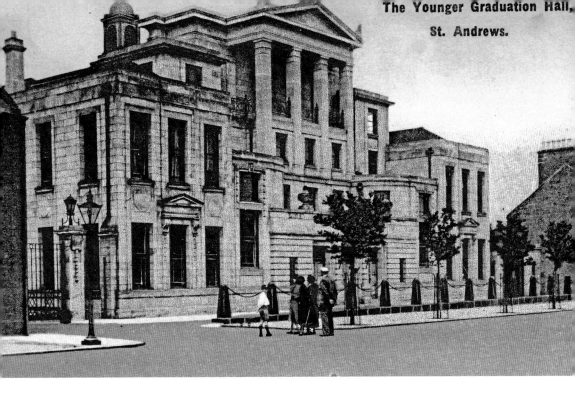

The Younger Graduation Hall, St. Andrews.

The University's Younger Graduation Hall of 1929 in North Street.

MARKET STREET

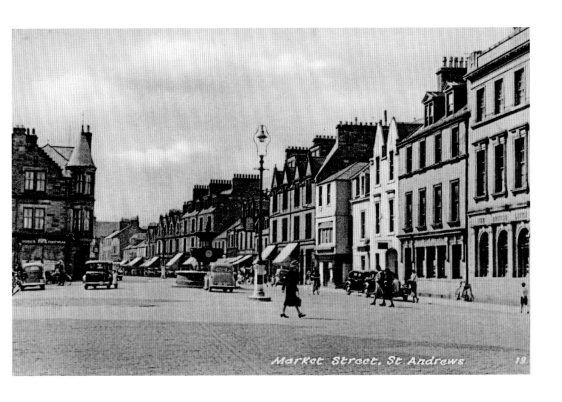

Market Street, St. Andrews.

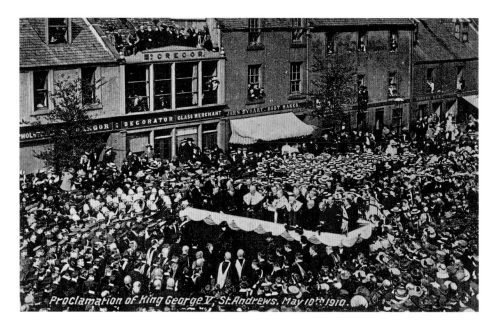

The End of Edwardian Age

The proclamation of George V 'at the Mercat Cross (Market Cross)' 10 May 1910, with John M'Gregor's shop in the background. On his promotional postcard John M'Gregor stands in front of his Market Street shop. Macgregor's house furnishing department in Market Street closed in 1986, when part of the business premises became Macgregor's Coffee Shop and Gift Gallery, which only recently closed and was redeveloped.

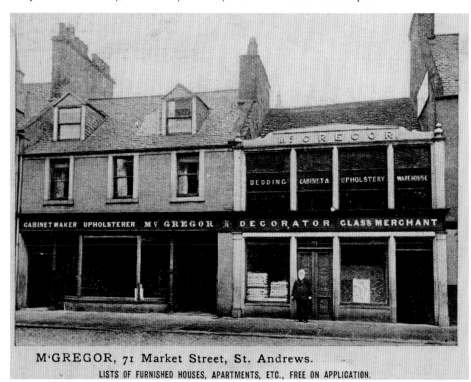

M'GREGOR, 71 Market Street, St. Andrews.
LISTS OF FURNISHED HOUSES, APARTMENTS, ETC., FREE ON APPLICATION.

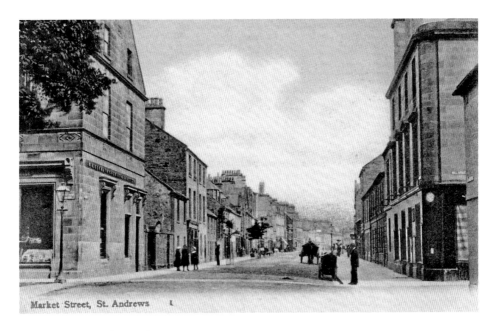

Market Street, St. Andrews

Market Street and a Market

Above, this view looking east shows the gentle curve of Market Street and predates the removal of the street's trees in 1936. The clock marks the junction of Market Street and Bell Street (developed 1847–86), while Kermath's Pharmacy (closed 1970) marks the function of Market Street with Greyfriars Garden (developed 1835–44). Woolworth's opened in 1936 on the site of the cottage in front of which a man stands beside a tree. Below, a Market Street market in and of the Red Cross, which took place on the outbreak of the First World War.

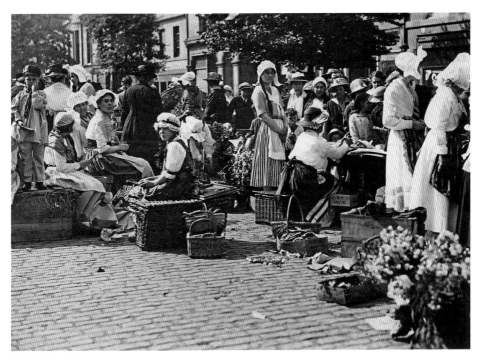

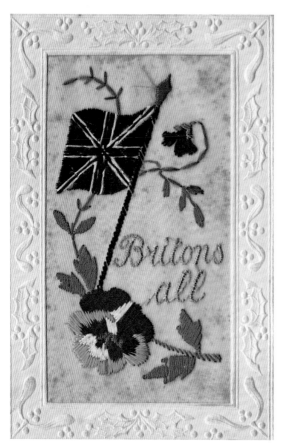

First World War Silks
Embroidered memento postcards with
a St Andrews connection that date from
the First World War. Such postcards
were immensely popular with soldiers
on the Western Front for sending home,
and treasured by those who received
them. Inexpensive, their delicate silk
organza and colourful hand-embroidery
were in direct contrast to the mud and
filth of trench warfare. Images included
birds, flowers, flags, greetings and
patriotic legends. They were first crafted
by French and Belgian women in their
homes or refugee camps but demand
was such that latterly they were made
in Paris factories.

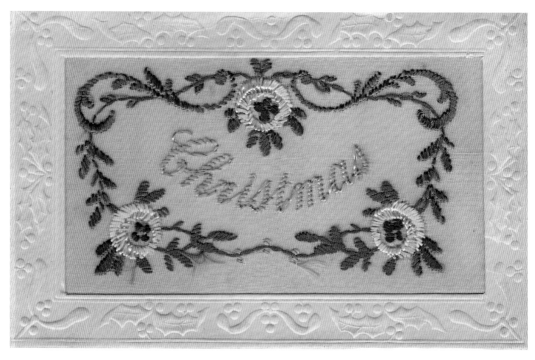

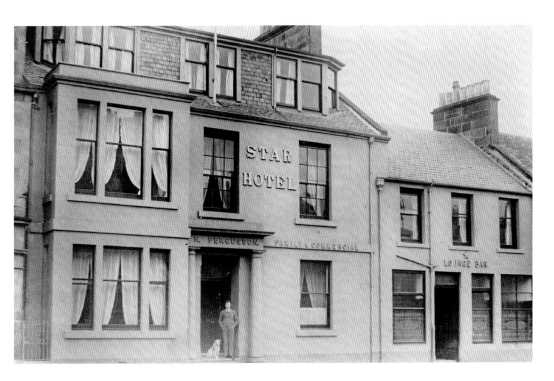

Market Street, Looking East, St Andrews
In the view above note the gable of the Star Hotel on the right. Built to cater for guests in an expanding Victorian St Andrews, it had stabling and a yard for coaches on the east side of Logies Lane. Demolished in 1982, the Star's site was redeveloped as retail premises. The hotel's pillared doorway was retained. Here the owner's son stands in the doorway, *c.* 1926.

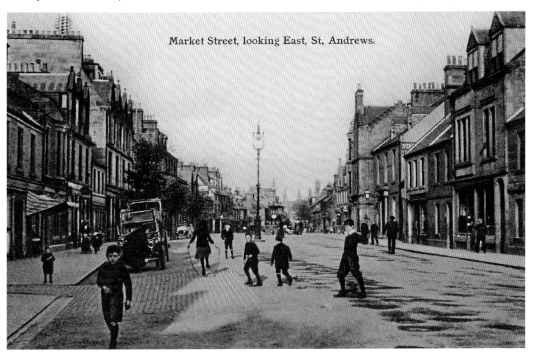

Market Street, looking East, St. Andrews.

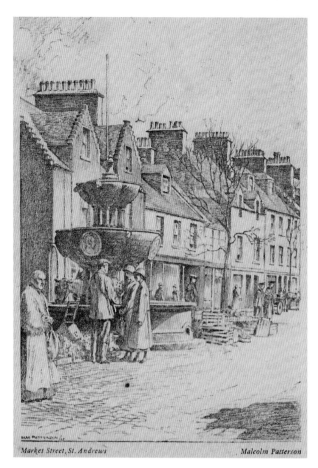

Market Street, St. Andrews *Malcolm Patterson*

The Fountain

Two charming postcards featuring the memorial fountain for the novelist George Whyte Melville of the Whyte Melville family of Mount Melville, who was killed 1878 on the hunting field. The Fountain, completed in 1880, was funded by public subscription. A fountain was chosen by his mother, Lady Catherine, to provide water for horses and dogs. After a long period, 'dry' July 2015 saw water flowing again from The Fountain. The fate after 1768 of the burgh's Market Cross is unknown. It stood near The Fountain. The Fairfield Stones (right) closed in 1992; the owners 'lived above the shop' in traditional fashion in the 1950s.

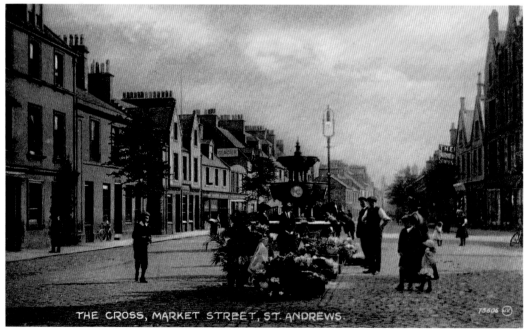

THE CROSS, MARKET STREET, ST. ANDREWS.

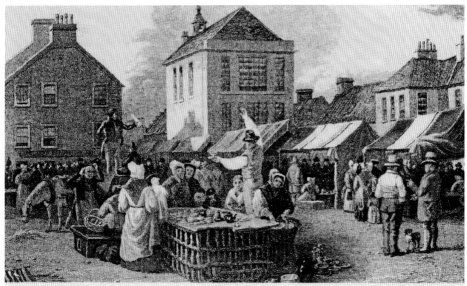

'THE FAIR', ST. ANDREWS HAY FLEMING COLLECTION

Old Market Street Buildings

Above, St Andrews town house or tollbooth on Market Day, 1838. Marked on a 'Plan of St Andrews, *c.* 1550', it underwent many alterations, and was demolished in 1862 on the completion of a new town hall in South Street. Coloured cobbles marked its site overlooking the market place until the 2011 upgrading of Market Street. Below, C. Grant's shop on the corner of Union Street and Market Street is remembered as Elsie Haggerty's paper shop; after 1926 the property with the barber's pole was demolished, as were houses on the west side of Union Street. The university's Buchanan Building of 1964 now occupies the site. The town house had an unusual mantelpiece, made of Kingsborns Marble – a shell limestone.

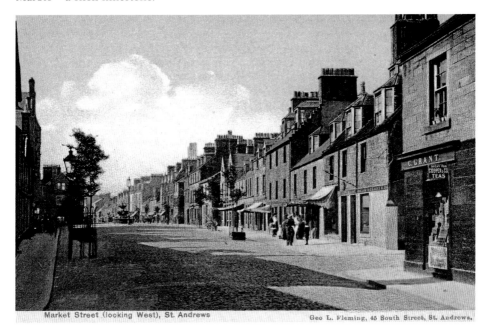

Market Street (looking West), St Andrews Geo L. Fleming, 45 South Street, St. Andrews.

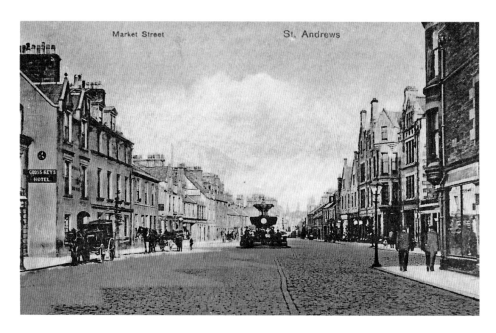

Vintage Views of Market Street

Postcards of Market Street, one looking east (above) and the other west (below). Common to both views is the corner property with the turret. Hogg's shoe shop (now closed) traded from its ground floor and basement. Change of use is a feature of some of the buildings featured below. The former British Linen Bank and the Royal Bank of Scotland (now relocated) now serve other commercial purposes, while the former Cross Keys Hotel (immediately east of the banks) is now, apart from its bar, a residential block. On the extreme left of the older view there is a glimpse of the Cross Keys, which was built c. 1850, and extended in 1865 as the town expanded. A cross keys sign indicates food, drink and accommodation being available.

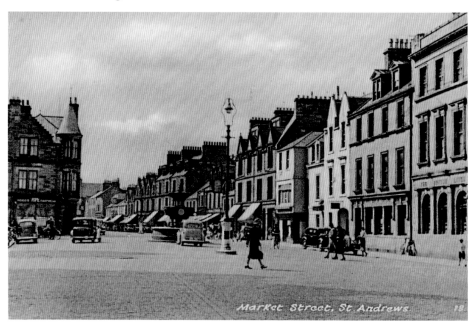

Market Street, St Andrews

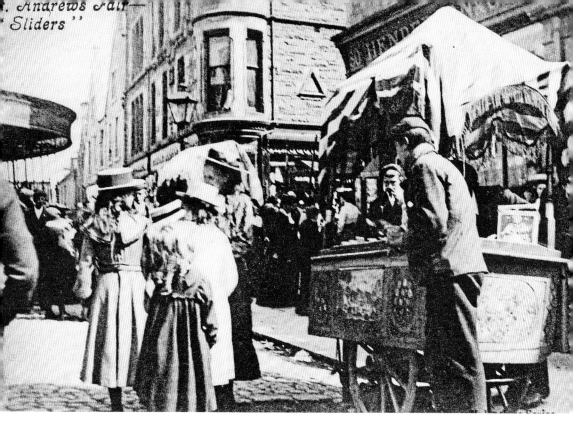

An Edwardian Lammas Market

An Edwardian 'St Andrews Fair – Sliders' shows Market Street at its intersection with Church Street. Part of the premises of W. C. Henderson (in business 1855–1985) is visible behind the ice-cream seller (a 'slider' is two wafers sandwiched together with ice-cream). Henderson's of No. 19 Church Street and No. 80 Market Street were printers, publishers, booksellers, stationers, and postcard publishers. St Andrews Lammas Market is still held in the main streets of St Andrews in early August. It is the only survivor of the burgh's five markets and is one of the oldest European medieval markets, and the oldest in Scotland.

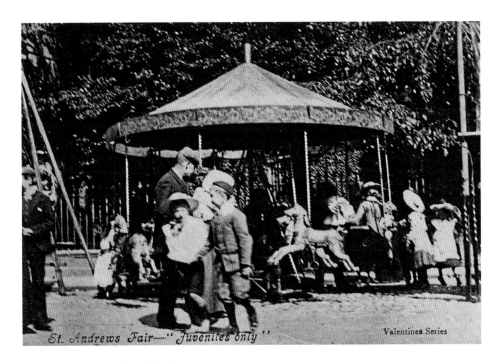

St. Andrews Fair—"Juveniles only" Valentines Series

Penny Dancing and Hobby-horses

Above, Edwardian children enjoy riding the hobby-horses at the Lammas Market. Below, the City Brass Band, *c.* 1902, plays for the 'penny dancing', once a popular feature of the fair. Behind the band is the West Front of the Holy Trinity Parish Church. The dancing was known as 'dancing at the back O' the Toon Kirk'. In the background is the English School of 1811, now St Andrews Public Library. Bright pink sugar hearts, 'market' sweeties and decorated gingerbreads, sold by stalls and local shops, were a feature of those early Lammas markets, and later ones too.

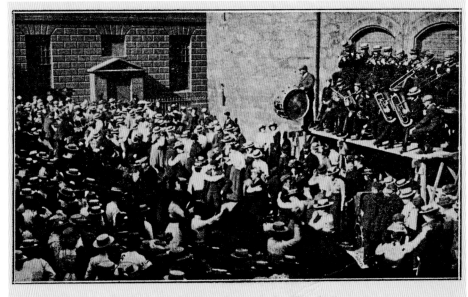

St Andrews Market—Dancing in Church Square

MORE VIEWS OF OLD
ST ANDREWS

St. Andrews 1275 Published by Fletcher & Son

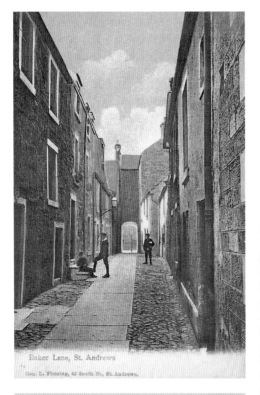

Baker Lane, St. Andrews

Geo. L. Fleming, 45 South St., St. Andrews.

Baker Lane, an Old St Andrews Wynd
Two atmospheric views of Baker Lane looking south to South Street, before its almost complete redevelopment in the 1950s by St Andrews Town Council. One of the four centuries-old wynds (lanes) that connect Market Street with South Street, its earliest known name was Baxter (baker) Wynd; then in the following two centuries it was known both as Bakehouse and Boxter Wynd. Its eighteenth-century name was Bakers' Wynd, and finally today's Baker Lane. Above, the lane's redevelopment saw the housing with the outside steps replaced by small council flats. Through the demolition of the house, (and right of behind the second figure) with their backs to the wall of the medieval garden of St John's House, the lane acquired the welcome amenity of an urban green space. Today the old wynd is an attractive mix of modern and period housing, its urban green space pretty with spring-flowering cherry trees and other colour in season. The gable end of St John's House in South Street, one of the oldest houses in St Andrews, is prominent in both views.

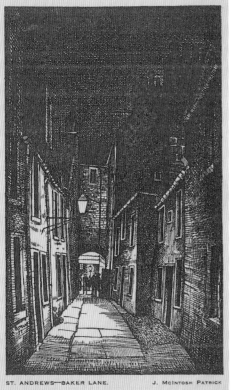

ST. ANDREWS—BAKER LANE. J. McINTOSH PATRICK

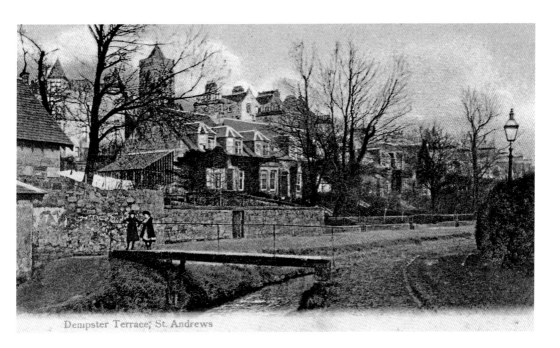

Dempster Terrace, St. Andrews

Views of Victorian St Andrews

Dempster Terrace was developed between 1870 and 1891, Queen's Gardens 1858–68 and the Victorian part of Queen's Terrace 1867–1901. Above, in the foreground is the Kinness Burn, and in the background the tower of the Episcopal Church of St Andrew (built 1867–69) in Queen's Terrace. Added to the church in 1892, the tower was dismantled in 1938–39. The property with the turrets is in Queen's Terrace. Beside the washing (left) is the former stable of Brooksby (now a house). At this time Brooksby's garden extended undeveloped from Queen's Terrace to the Kinness Burn.

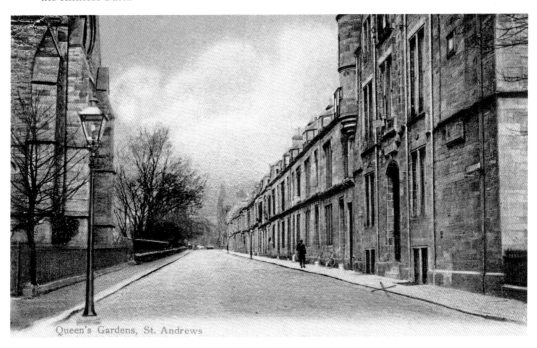

Queen's Gardens, St. Andrews

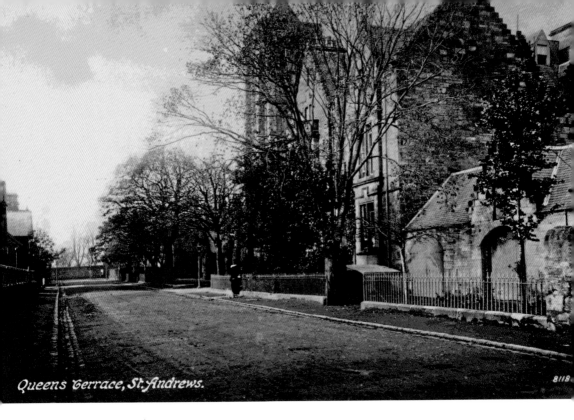

Queens Terrace, St. Andrews.

8118

Named for a Queen!

A view of Victorian Queen's Terrace, originally called Queen Street Terrace. This view looks west to the grounds of Madras College, whose enclosing boundary wall then had no entrance gateway from or to Queen's Terrace. On the left the entrance porch of this Victorian property remains in position. Queen's Terrace was built on the southern perimeter of old St Andrews, and developed along part of the easterly section of the old walk, which ran beside the burgh's open mill lade or lead on its way to the harbour. John McIntosh, a town councillor in 1856 and a bailie in 1869, ordered the covering of the lade. On the right the small building no longer stands. The large building beside it is now the university student residence St Regulus Hall.

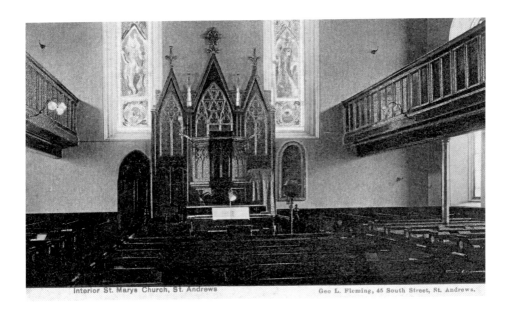

Interior St. Marys Church, St. Andrews Geo L. Fleming, 45 South Street, St. Andrews.

Two St Andrews Churches

St Mary's Church, built in 1839 and now the Victory Memorial Hall, provided necessary extra seating for the Holy Trinity Church. As a church it was in use until the reconstruction of Holy Trinity (1907–09) was complete, when it became redundant. St Mary's Place was not so named until St Mary's Church was built. Hope Park Church was built in 1865 on the opposite side of the road, when the church, today's Hope Park and Martyr's Parish Church, was part of the united Presbyterian Kirk. Prior to 1865, the congregation had occupied a chapel at No. 52 North Street, as of 1827. Alexandra Place was developed between 1869 and 1870 and named for Alexandra, Princess of Wales, later Queen Alexandra (*d.* 1925). On the right is an entry to the former Wilson's Garage, then sited at No. 193 South Street and Alexandra Place. On the left are the railings of Alfred Place, named after Queen Victoria's second son Prince Alfred (1844–1900), and developed 1862–1870.

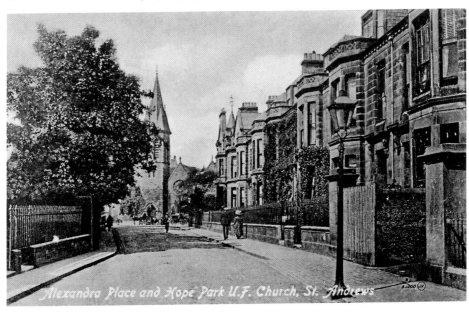

Alexandra Place and Hope Park U.F. Church, St. Andrews

73

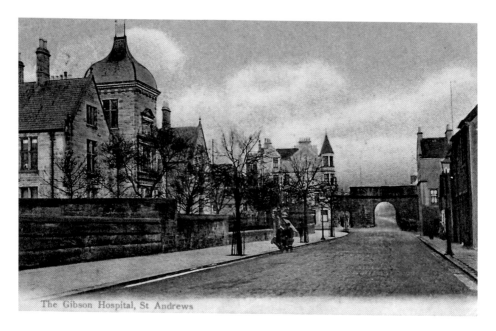

The Gibson Hospital, St Andrews

A Hospital and a Church

Above, the Gibson Hospital – 'The Gibson' or Gibson House – stands at the corner of Argyle Street and City Road, It was opened in 1882 and was built and funded by a bequest of William Gibson of Duloch, to provide care for the deserving aged and infirm of the parishes of St Andrews and St Leonard's, in more comfortable surroundings than those of a Victorian poorhouse. Below, St Leonard's Parish Church was built in 1904 in Hepburn Gardens on land that was part of the endowment of the first St Leonard's church. The chapel of the pre-Reformation St Leonard's pilgrim hospice was refounded as St Leonard's College in 1512. When the colleges of St Salvator and St Leonard united in 1747, the congregation of St Leonard's Church worshipped in the university chapel until St Leonard's Church was built in 1904. Today the university's St Leonard's College Chapel is beautifully restored.

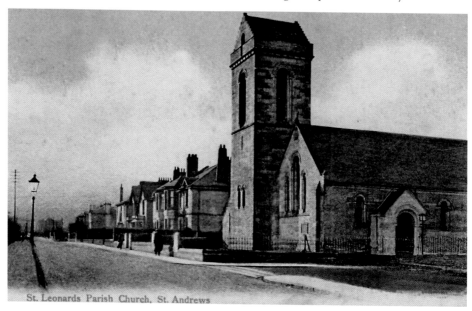

St. Leonards Parish Church. St. Andrews

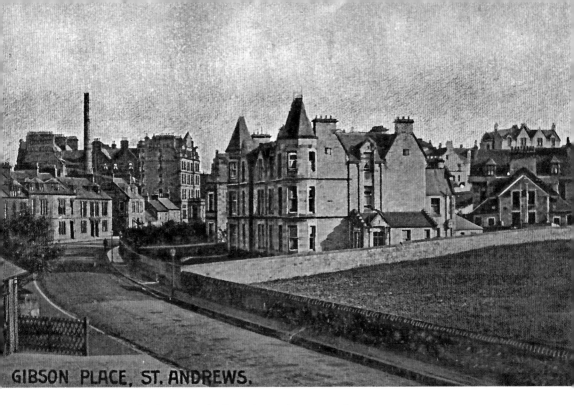

GIBSON PLACE, ST. ANDREWS.

Gibson Place and Pilmour Links from the Petheram Bridge

This view is taken from the Petheram Railway Bridge of 1887 that no longer exists, although its name lives on in the Petheram Bridge car park. The last train ran over the bridge on 6 January 1969 and the bridge was dismantled soon after. Prominent in the background is Rusack's Hotel, with its laundry chimney. Henry Petheram (1845–95) was the St Andrews district county road surveyor, who oversaw the construction of the 1887 Petheram Bridge. Victorian Gibson Place is seen on the right of the view.

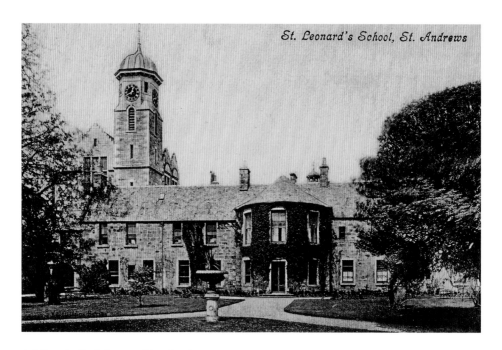

St. Leonard's School, St. Andrews

A Historic Building and its Garden

Views of St Leonard's School and its garden. Common to both postcards is the school clock tower of 1901. The long two-storey building was once the western part of the residential building occupied by the professors and students of the university's St Leonard's College. 1747 saw St Leonard's College amalgamated with the university's St Salvator's College for financial reasons, to form United College; the St Leonard's buildings not required by the university were sold, and that included the two-storey building now part of St Leonard's School. Once the home of Sir Hugh Lyon Playfair, Provost of St Andrews from 1842 until his death in 1861. Playfair Terrace, developed 1847–50, is named after him. Sir Hugh's home was named St Leonard's West.

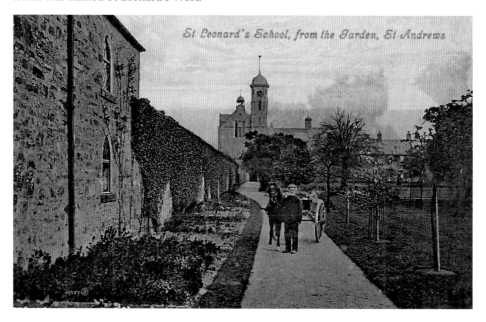

St Leonard's School, from the Garden, St Andrews

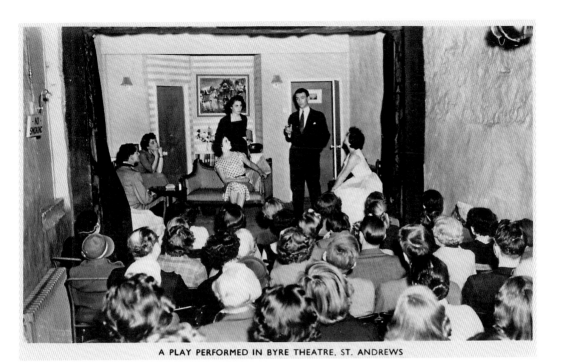

A PLAY PERFORMED IN BYRE THEATRE, ST. ANDREWS

A Little Toy Theatre

There have been three Byre Theatres in the town's Abbey Street, This postcard shows a play being performed in the first 'Byre' of 1933–1969. A tiny theatre with seventy-four seats and a 12 x 14-feet stage, it provided an intimate theatrical experience. A converted pantiled byre (cowshed), it was part of the steading of the old Abbey Street Dairy Farm, one of the old St Andrews burgh farms. The theatre was accessed via a pond (a covered entry way) and the cobbled farmyard. The theatre's founder and moving spirit was St Andrean A. B. Paterson (1907–89), journalist and playwright, and a group of friends who were also interested in the theatre. The 1969–70 widening of Abbey Street swept away the first Byre Theatre, which was succeeded in medieval Abbey Street by the second Byre Theatre (1970–96) and finally the third and present Byre.

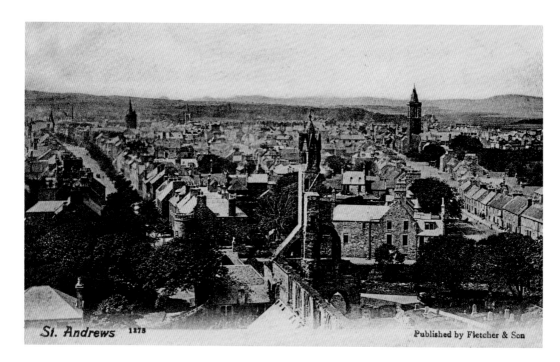

St. Andrews 1273 Published by Fletcher & Son

Towers and Spires

Above, St Andrews from St Regulus Tower in the cathedral precinct. The view shows South Street and North Street converging on the cathedral. The focal point of centre of medieval St Andrews is the west front of the cathedral, rebuilt in 1273–79 originally with a large three-arched porch. Left, is Holy Trinity Church tower and spire, right that of St Salvator's, and in the distance Hopel Park Church tower and spire. Below, this view from St Salvator's College tower looks east to the cathedral reins, and the site of the ancient settlement of Kilrymont with its centre on the high ground at Kirkhill. Kilrymont has been used in modern St Andrews for street names and a school.

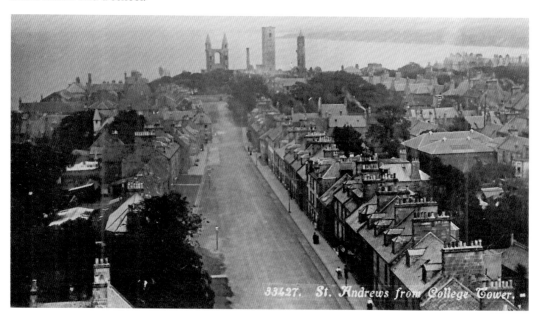

33427. St. Andrews from College Tower.

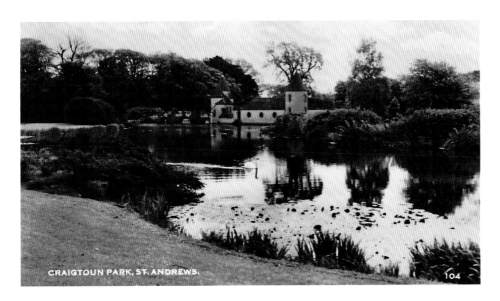

CRAIGTOUN PARK, ST. ANDREWS. 104

A Valuable Amenity

Views of the 'Dutch Village' at Craigtown Country Park near St Andrews. The Dutch Village was one of the features of the landscaped gardens and grounds of Mount Melville House, part of the Mount Melville Estate, owned by James Younger (1856–1946). 1947 saw the mansion and its grounds acquired by Fife County Council. The mansion became a maternity hospital then a care home (closed 1992), and its gardens and grounds Craig Town Country Park. The historic Mount Melville Estate was originally called Craigtown. The Georgian Mansion, which was demolished by James Younger and replaced by his Mount Melville House, was the home of the novelist Major George Whyte Melville (1821–78), who is commemorated in The Fountain of 1880 in Market Street. Craigtown Country Park is rich in birdlife, wildlife and trees. Other amenities include bowling, boating and putting. The architect who designed Mount Melville House and landscaped its gardens was Paul Waterhouse. He also designed the university's Lounges Graduation Hall.

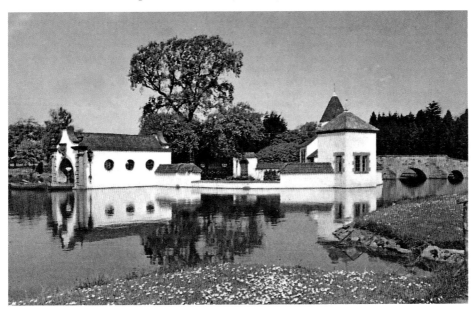

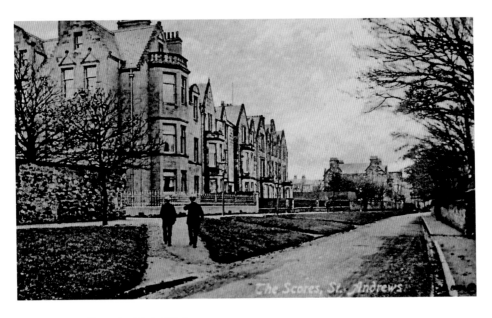

A Marine Walk and a Holy Well

The Scores stretches west from St Andrews Castle to the bottom of Golf Place, the East Scores from the castle to the harbour. The Scores was known in the early nineteenth century as 'The Scores Walk', a fashionable clifftop walk overlooking St Andrews Bay, where the sea air complemented the delights of the private marine baths developed in 1810 by Col Dewar and Capt Vilant a little west of the castle. The baths were demolished in 1967. The late nineteenth century saw the full development of The Scores in a variety of architectural styles where large properties overlooked St Andrews Bay. St Andrews Cathedral was abandoned after the Reformation of 1559. The area adjacent to the ruined cathedral became the chief burial ground of the city, with many interesting historic tombstones and monuments. An Edwardian postcard of the nearby East Cemetery shows where can be entered from the Pends Road. The well's name is a traditional one. It is sited not far from the cathedral's granary, no longer extant. The cathedral precincts had a number of wells.

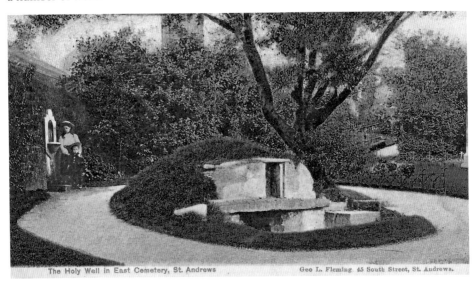

The Holy Well in East Cemetery, St. Andrews Geo L. Fleming 45 South Street, St. Andrews.

GOLF

SEGOL THETFORD NORFOLK

Marcus Ward's Series, No. 10.—"Golf."

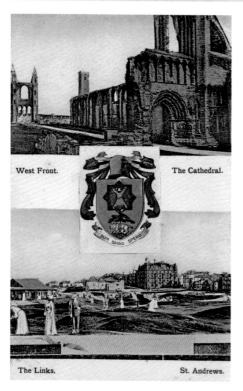

West Front. The Cathedral.

The Links. St. Andrews.

Two Clubhouses and Golf for the Ladies
1867 saw the formation of St Andrews Ladies
Golf Club, and their golf was putting. Originally
its membership was limited to 100 ladies and
fifty gentlemen. Today The Ladies Putting Club
has its own clubhouse and putting green, the
undulating 'Himalayas'. The card below features
both the Ladies Golf Club, House and that of the
Royal and Ancient Golf Club, built in 1853–54
with later additions, and the 'Himalayas'. The
Jubilee Course originated as a twelve-hole course
for ladies and beginners in June 1897. It was not
until the New Golf Course was opened in 1895
that the original 'golfing grounds' of St Andrews
were named the 'Old Course'.

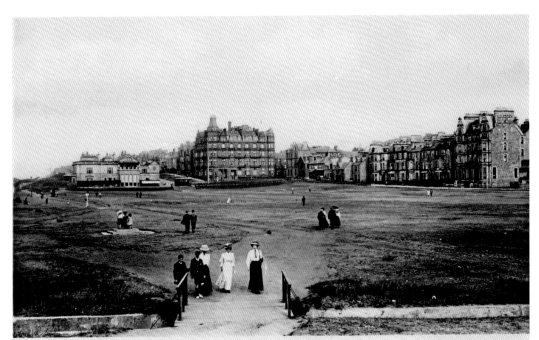

Series 527-2 **St. Andrews from the Links.** Davidson Brothers.

Down at the Links

An early view of the Old Course. In the background from the left, the Royal and Ancient Golf Club House, the Grand Hotel, and on the right, Rusack's Marine Hotel as it was then. Opened in 1892 by the Rusack family of hoteliers, the hotel provided every comfort for its guests, including the Palm House. The party in the foreground is crossing the small sandy Swilcan on its way to the sea. After the 1862 demolition of the old town house, stones from it were used to line its banks.

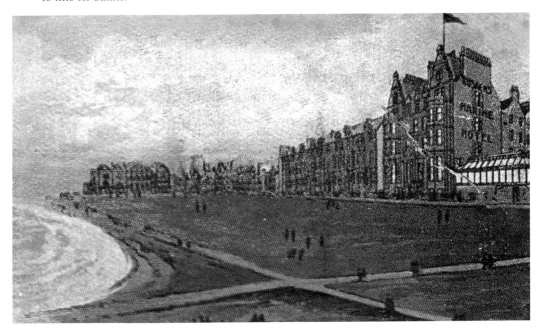

83

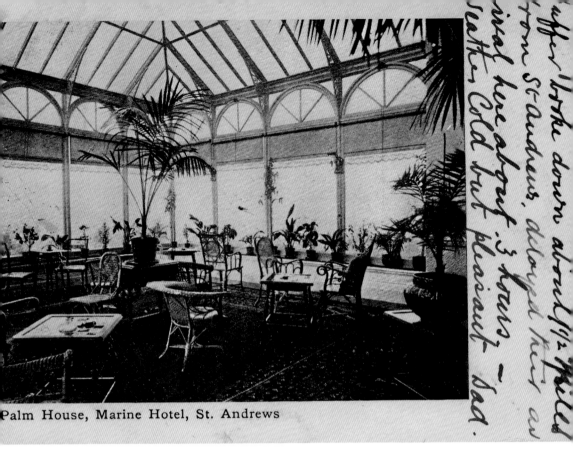

Palm House, Marine Hotel, St. Andrews

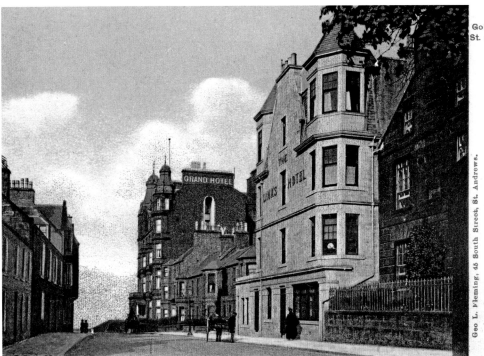

Golf Place,
St. Andrews

Geo. L. Fleming, 45 South Street, St. Andrews.

The Grand

The Grand Hotel, built of red Dumfries sandstone, was opened in 1896, with every comfort for its guests and panoramic views of 'the golfing grounds', St Andrews Bay, and the hills beyond. Its site was that of the former Union Parlour, used by members of the Royal and Ancient Club, before their clubhouse was built in 1854. Occupied by the RAF during the Second World War, the Grand became a St Andrews University student residence, Hamilton Hall, in 1949. After recent redevelopment it is now the Hamilton Grand. The Links Hotel got its licence in 1863 and Golf Place was developed 1830–37.

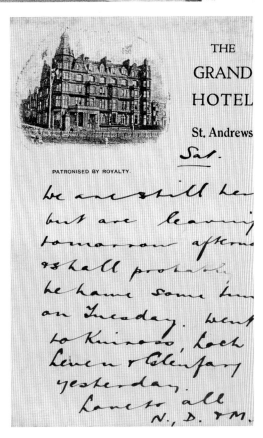

THE
GRAND
HOTEL
St. Andrews

PATRONISED BY ROYALTY.

The Links, St. Andrews

Putting for Pleasure on the Bruce Embankment
Views of putting on the Bruce Embankment, which was laid out as a public putting course in 1914. The Bruce Embankment was named by St Andrews Town Council in 1896 to commemorate the efforts of George Bruce (1825–1904) in the reclamation from the sea that began in 1893. The path edged by the white posts was laid down by old Tom Morris.

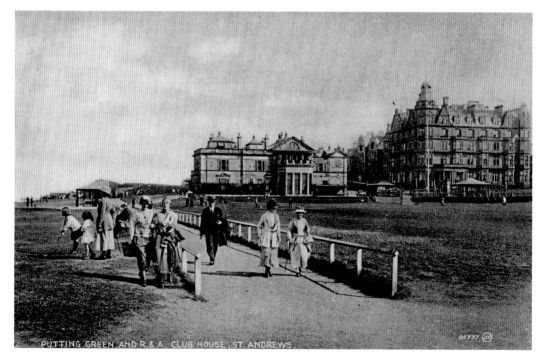

PUTTING GREEN AND R.& A. CLUB HOUSE, ST. ANDREWS

Golf – 'an elegant amusement and conducive to health' – and below, a fine photo by G. M. Cowie of the St Andrews Railway which ran between 1852 and 1969.

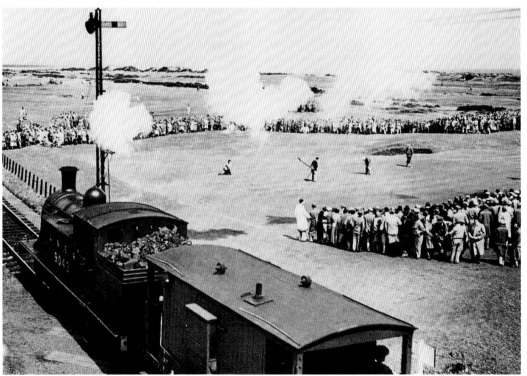

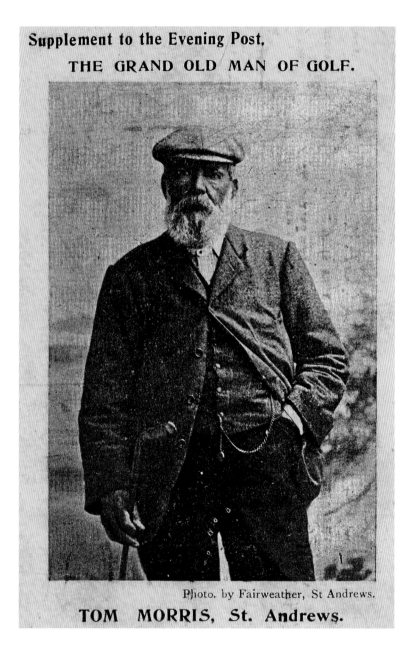

Supplement to the Evening Post,

THE GRAND OLD MAN OF GOLF.

Photo. by Fairweather, St Andrews.

TOM MORRIS, St. Andrews.

The Grand Old Man of Golf

'Old Tom' Morris (1821–1908) is famous in the world of golf. As a professional golfer, he won the Open Championship in 1861, 1862, 1864 and 1867. Morris returned to his native St Andrews in 1865 when he was appointed keeper of the green of the Old Course, and the Royal and Ancient's honorary golf professional. A skilled maker of golf balls and clubs, and skilled in green-keeping and designing golf courses, he established a business and shop in The Links overlooking the Old Course that is still open for business. 'Old Tom' is buried in the cathedral cemetery, as is his son 'Young Tom' Morris (Tommy) who died on Christmas Day 1875, aged twenty-four. As a gifted professional, 'Young Tom' won the Open in 1868, 1869, 1870 and 1872. Tom Morris Drive, of 1951, is named for father and son. The Old Course's eighteenth hole bears Old Tom's name.

GREEN AND PLEASANT PLACES

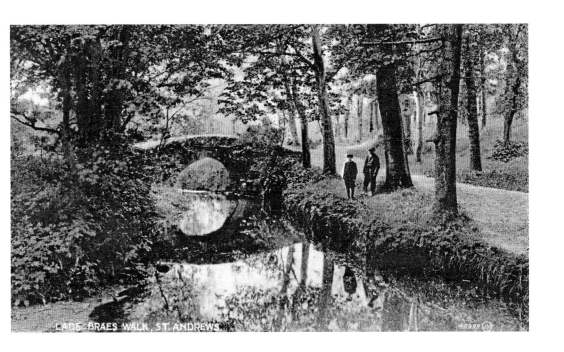

LADE BRAES WALK, ST. ANDREWS.

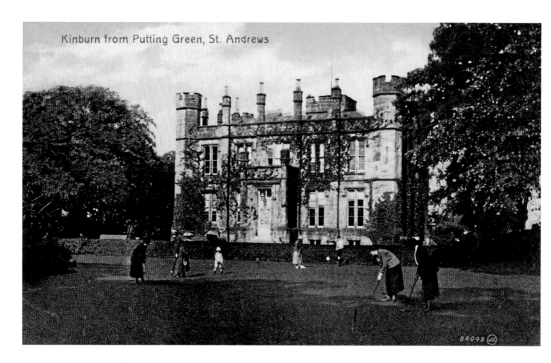

Kinburn from Putting Green, St. Andrews

Kinburn House and Its Park

Kinburn House and its grounds were acquired by St Andrews Town Council in 1920 to be used as a public park. Today Kinburn House is St Andrews Museum, with exhibition space and a café, complemented by the park's seasonal bowling, putting and tennis. Kinburn House and its grounds were built and laid out (1854–56) on former pasture, with panoramic views north over a then undeveloped North Hough. The mansion was built by St Andrews man Dr David Buddo (1800–60) on his retirement from the Indian Medical Service.

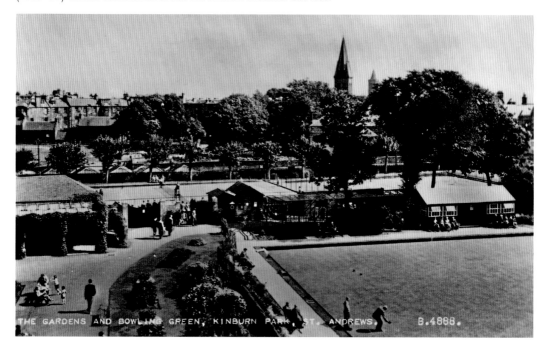

THE GARDENS AND BOWLING GREEN, KINBURN PARK, ST. ANDREWS. B.4868.

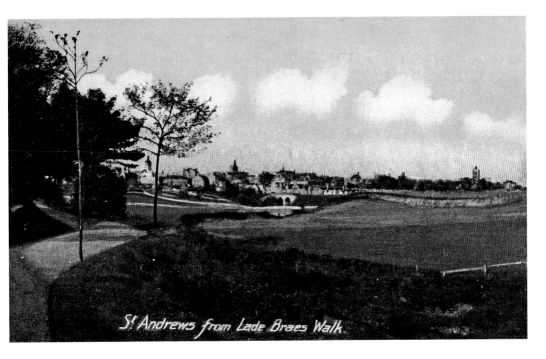

St Andrews from Lade Braes Walk

Two Views of an Older St Andrews

'St Andrews from Lade Braes Walk' shows, on the right, the ground which became the Cockshaugh Park, and in 1954 the King George VI playing field. 'St Andrews from the East Sands', a tranquil view of around 1908, shows the East Sands and the East Bents, which stretch from the harbour to the Kinkell Braes. Before St Andrews ceased to be a lifeboat station in 1938, the lifeboat was housed at the East Bents. 1896 saw the the Gatty Marine Laboratory built at the East Bents. This area has seen considerable development, including housing and the building of The East Sands Leisure Centre.

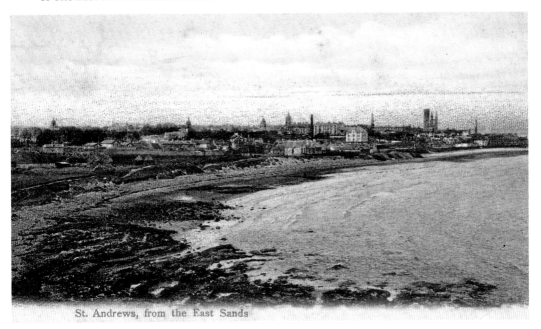

St. Andrews, from the East Sands

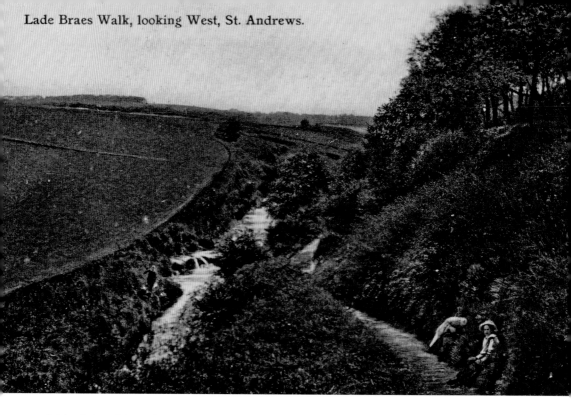

Lade Braes Walk, looking West, St. Andrews.

A Much-loved Amenity

The Lade Braes Walk. This favourite walk of many today was created around 1908 in the rocky ravine which encompassed the Kinness Burn and the common lade (lead), whose fast-flowing waters powered the mills of old St Andrews and supplied the priory's needs. The Lade Braes Walk was pioneered and fostered by the Victorian town councillors John McIntosh and John Milne. The lade was covered over, with numerous trees and shrubs creating a place of natural beauty. The views show open country, the development of which would begin in the 1960s.

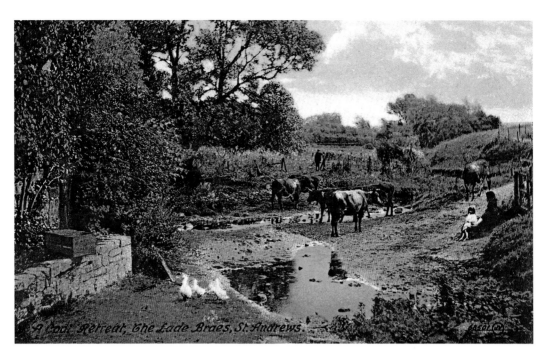

A Cow Retreat, The Lade Braes, St. Andrews.

Green and Pleasant Places
Views suggestive of bygone summer days. James Patrick belonged to a family well known in fine art, postcard and photographic publishing in Fife and Edinburgh.

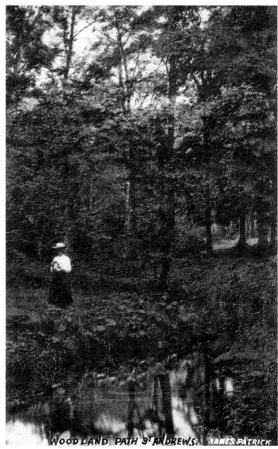

WOODLAND PATH S.T ANDREWS. JAMES PATRICK

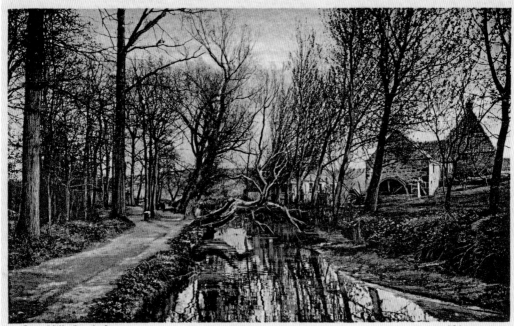

Law Mill, St. Andrews.

RELIABLE SERIES.

The Lade Braes

Above is the Law Mill or Nether Mill of Balone. Its exact age is unknown, but there is a reference to it in 1570. In its working days, its waterwheel, with its two sets of grinding stones, was powered by water from the Lumbo and Kinness burns. Thomas Nicol (or Nicolls) who ground corn and barley, occupied the mill from 1848 to 1913. By 1905 there was little work for small local millers and the waterwheel fell into disuse. Below is the 1792 Law Mill Bridge that spans the Kinness Burn and leads to Law Mill, sometimes referred to as Law Green Mill.

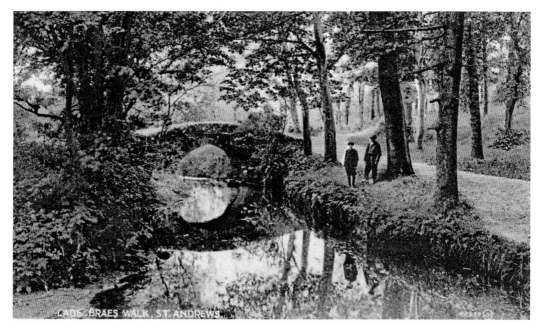

LADE BRAES WALK, ST. ANDREWS.

POSTSCRIPT

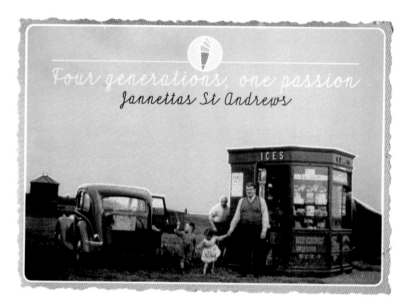

Delicious Ice-cream!
As a postscript, I have included two modern postcards, produced by Jannettas of No. 31 South Street, St Andrews, which carry on the tradition of using postcards for publicity. The images reproduced are family ones. 1908 Saw Bennett Jannetta arrive in St Andrews where he first made his vanilla ice-cream at No. 31 South Street. Above, members of the Jannetta family outside their kiosk at the West Sands. Over half a century of town rubbish was used to create the first West Sands Road, beginning in 1918. Below, do you want a wafer or a cone? Such ice-cream vendors were very much part of summer in an older St Andrews.

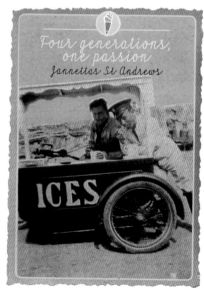

SOURCES & ACKNOWLEDGEMENTS

All the postcards reproduced in *St Andrews: The Postcard Collection* are from the postcard collection of the St Andrews Preservation Trust, unless otherwise acknowledged. The author wishes to thank the Trust for their facilities, and also its curator, Sam Bannerman, for help in sourcing the postcards. The text of this book is based on my previous research and writing on St Andrews.

ABOUT THE AUTHOR

Helen Cook has known St Andrews since childhood. *St Andrews: The Postcard Collection* is her fifth book on St Andrews, whose multifaceted story continues to fascinate her, and which she continues to write about.